W9-AXG-635

OCT 1 9 2005

10-26-13 (20)
7-13-16 (21)
10-31-17 (24)

ACRYLICS
THE**WATERCOLOR** ALTERNATIVE

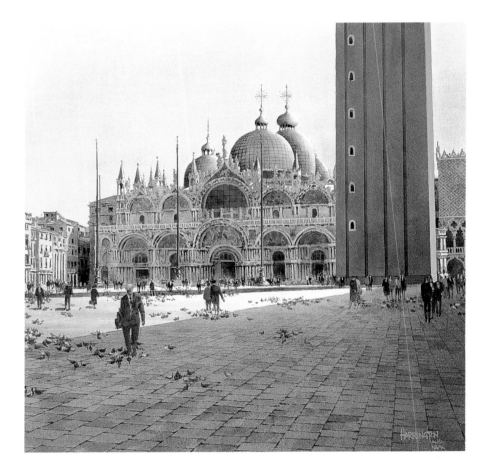

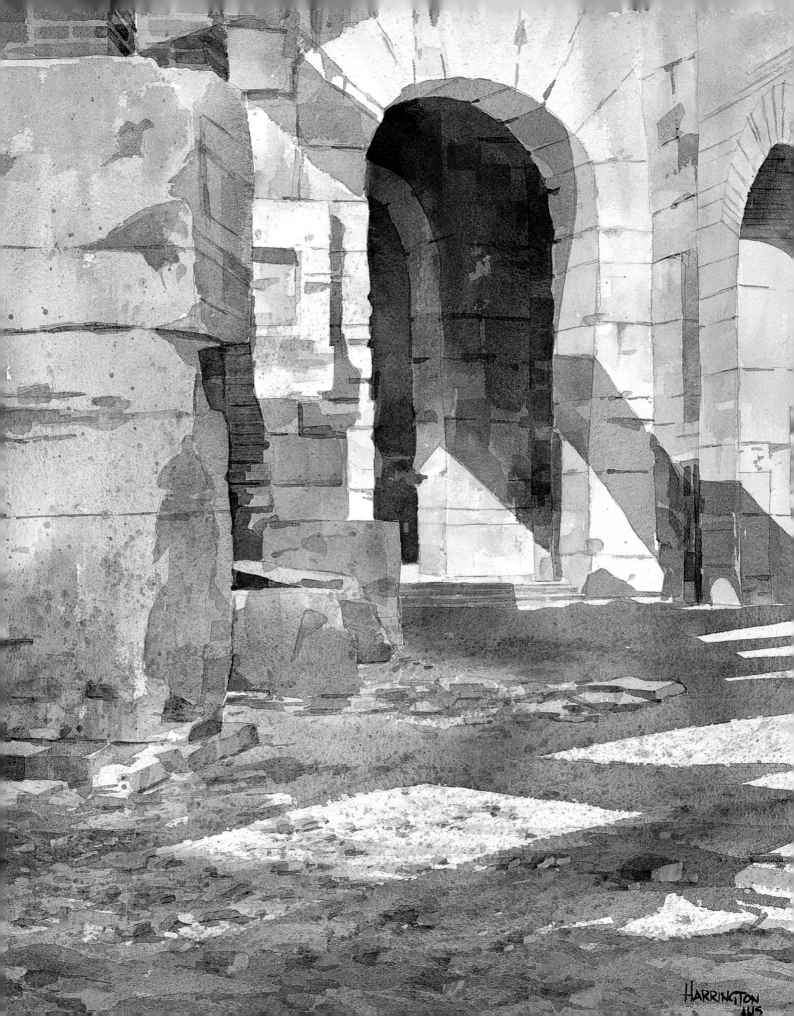

ACRYLICS
THE WATERCOLOR
ALTERNATIVE

25 demonstrations
for achieving
beautiful paintings

CHARLES HARRINGTON, AWS, NAPA

NORTH LIGHT BOOKS
CINCINNATI, OHIO
www.artistsnetwork.com

COLISEUM
300-lb. (640gsm) cold-pressed watercolor paper / 29" x 21" (74cm x 53cm)

About the Author

The diversity of his life and professional experience has given Charles Harrington a unique and perhaps unconventional perspective on the world of fine art. After earning two degrees in architecture from the University of Arkansas, he spent fifteen years as a practicing architectural designer and illustrator. He then returned to academia, earning his Masters in Architecture from Oklahoma State University. Upon graduating, Charles accepted a faculty position with the School of Art and Architecture at Louisiana Tech University, teaching architecture courses as well as drawing and water-media painting. Finally he was able to indulge in both of his passions—fine art and architecture—in the same venue. Charles taught for twenty-five years before leaving Louisiana Tech in 2003 to pursue fine art full time. He now devotes his time to painting, writing and conducting painting workshops.

Charles Harrington is a signature member (DF) of the American Watercolor Society and the International Society of Acrylic Painters. His work has been shown in the American Watercolor Society, National Acrylic Painters Association, The American Artist's Professional League, Allied Artists of America, Watercolor USA, Arts for the Parks top 100 and numerous regional exhibitions. Publications include *American Artist*'s Watercolor 88, *Watercolor Magic*'s Autumn 1996 edition, and *The Artist's Magazine*'s December 2004 edition. He currently resides in Bella Vista, Arkansas.

Other fine North Light Books are available from your local bookstore, art supply store or direct from the publisher.

Distributed in Canada by Fraser Direct
100 Armstrong Avenue
Georgetown, ON, Canada L7G 5S4
Tel: (905) 877-4411

Distributed in the U.K. and Europe by David & Charles
Brunel House, Newton Abbot, Devon, TQ12 4PU, England
Tel: (+44) 1626 323200, Fax: (+44) 1626 323319
Email: mail@davidandcharles.co.uk

Distributed in Australia by Capricorn Link
P.O. Box 704, S. Windsor NSW, 2756 Australia
Tel: (02) 4577-3555

09 08 07 06 05 5 4 3 2 1

Library of Congress Cataloging in Publication Data
Harrington, Charles.
 Acrylics: The Watercolor Alternative / Charles Harrington.— 1st ed.
 p. cm
 Includes biographical references and index.
 ISBN 1-58180-586-1
 1. Acrylic painting—Technique. I. Title.

ND1535.H357 2005
751.4'26—dc22 2005008497

Edited by Layne Vanover

Designed by Leigh Ann Lentz

Production art by Joni DeLuca

Production coordinated by Mark Griffin

F+W PUBLICATIONS, INC.

Metric Conversion Chart

To convert	to	multiply by
Inches	Centimeters	2.54
Centimeters	Inches	0.4
Feet	Centimeters	30.5
Centimeters	Feet	0.03
Yards	Meters	0.9
Meters	Yards	1.1
Sq. Inches	Sq. Centimeters	6.45
Sq. Centimeters	Sq. Inches	0.16
Sq. Feet	Sq. Meters	0.09
Sq. Meters	Sq. Feet	10.8
Sq. Yards	Sq. Meters	0.8
Sq. Meters	Sq. Yards	1.2
Pounds	Kilograms	0.45
Kilograms	Pounds	2.2
Ounces	Grams	28.3
Grams	Ounces	0.035

Dedication *To my life partner and wife, Daphne Harrington.*
Without her love, support and just plain hard work, this book could not have happened.

Acknowledgments

Thank you to the folks at North Light, especially Jamie Markle for seeing this book as a possibility, and Layne Vanover whose editing and coordination skills have made this an enjoyable venture. She makes me look much better than I deserve.

My sincerest graditude to my sister-in-law, Dr. Helen Inbody, and my artist friend, Albino Hinojosa, whose consistent encouragement has meant more to me than they will ever know.

And how could I forget my many students, who over a period of twenty-five years have encouraged and challenged me, forcing me to grow as a teacher and painter. My hope is that I have touched your life as profoundly as you have mine.

Most importantly, I acknowledge my ultimate source of life, strength and guidance, and the author of my talent who sustains me in all things—God.

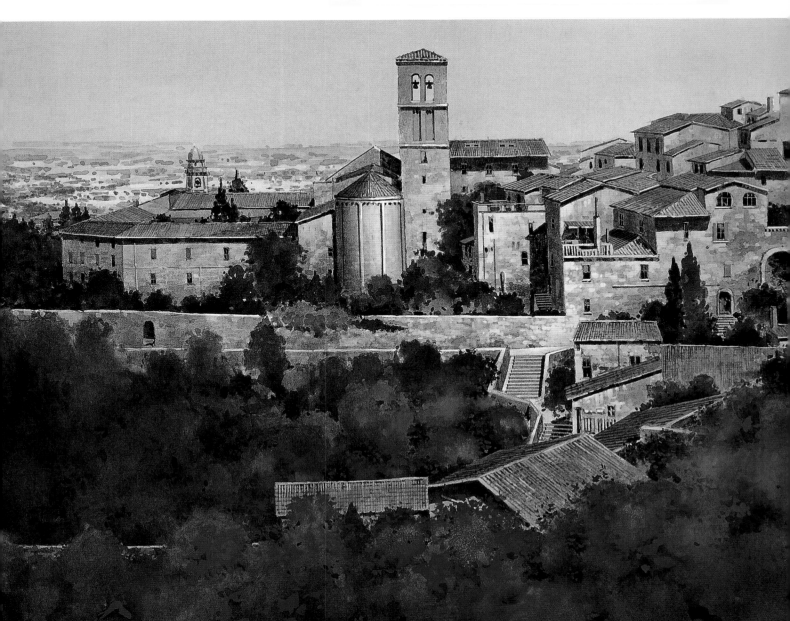

HILL TOWN
Fredrix watercolor canvas / 16" x 20" (41cm x 51cm)

Table of Contents

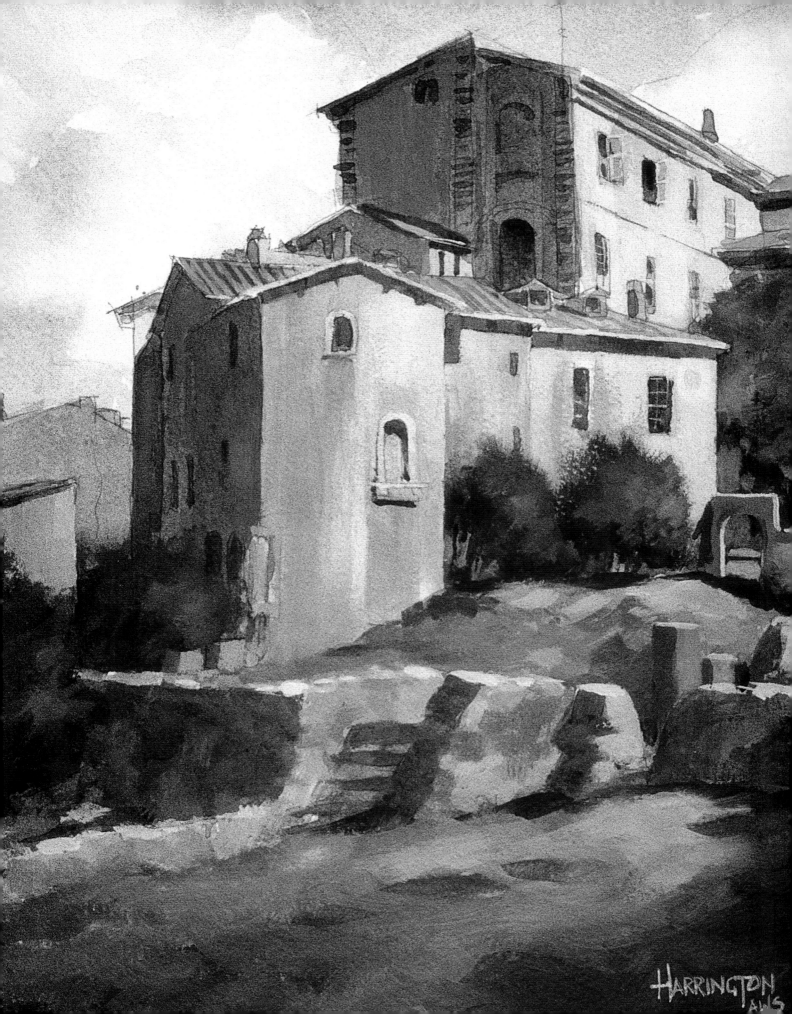

Introduction

When I first realized that I was interested in being a painter, I was immediately drawn to the aesthetic of watercolor. It possessed such luminosity, and its transparent nature gave it a life unlike any other medium. These were the qualities that I wanted to showcase in my own paintings, so I set out on my journey, determined to work exclusively with watercolor.

Suffice to say, it didn't take long to learn what all watercolorists eventually learn—watercolor has some frustrating limitations. It was while attempting to overcome or circumvent these limitations that I discovered acrylics. I learned that with acrylics, I could retain most of the positive attributes of watercolor while exceeding the capabilities of watercolor in a number of important areas.

The demonstrations in this book will emphasize four important attributes of acrylics that exceed those of watercolor, making acrylics an attractive and capable alternative to watercolor. In specific:

Acrylics allow multiple glazes to be applied with less risk of compromising previous applications. This minimizes the muddy effect that often results when consecutive applications of watercolor are applied over each other.

Acrylics accommodate the use of a masking medium over painted areas without lifting pigment from previous applications. To those of us who use a masking medium, this offers a significant advantage.

Acrylics offer a comfortable merging of transparent, translucent and opaque passages within the same painting. This is a liberating attribute to watercolorists since opaque passages in an otherwise transparent watercolor painting usually appear to be an uncomfortable compromise.

Acrylics are more durable than watercolor. Because acrylic applications are virtually insoluble when dry, they are not as vulnerable to moisture damage as other water media. If painted on a proper support, they can be framed without the protection of glass.

It is my belief that after a hands-on experience with the demonstrations in this book, you too will fall in love with this versatile medium, making acrylics your first choice for creating watercolor-like paintings.

REFLECTIONS IN A LOUISIANA SWAMP
300-lb. (640gsm) cold-pressed watercolor paper / 21" x 14" (53cm x 36cm)

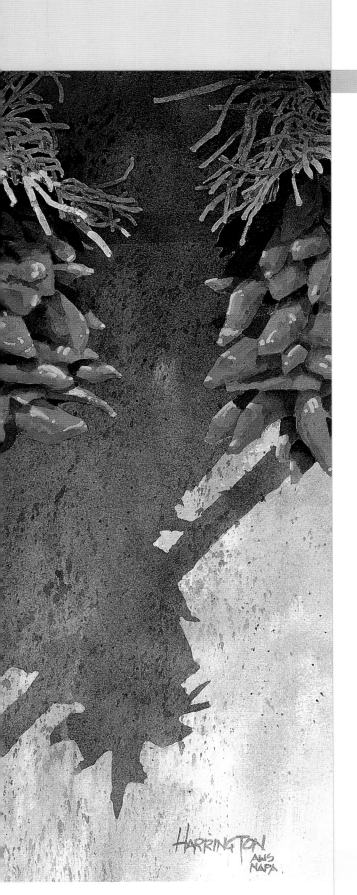

CHAPTER ONE

Getting Started

On the street where I live, builders are constructing several new houses. As I observe them work, I realize that the process one undergoes to create a successful painting is not unlike that of building a house. In fact, parallels exist between these two tasks from start to finish. For instance, before a builder can begin constructing a house he must first prepare a work space that is efficient. After organizing the space, he then brings in the stacks of materials that will eventually become the components of the finished house. And, of course, the builder can't begin construction without the tools of his trade, so he must take time to gather the equipment necessary for the job. Only when all of these steps have been completed can the builder begin work on the house. As an artist, you must make similar preparations before you can work on your masterpiece. In this chapter we will discuss such preparations, including choosing your work space, gathering the necessary materials, and collecting the tools you'll use to convert your materials into a painting, equipping you with everything you'll need to get started.

CHILI RISTRAS
300-lb. (640gsm) cold-pressed watercolor paper / 21" x 29" (53cm x 74cm)

Finding a Place to Work

Whether you paint occasionally as a relaxing hobby or painting is the primary focus of your daily activities, the quality of your work environment is an important key to your success. Your work space should be one that encourages creative thought and permits concentration on your art. It should be efficient and comfortable, with all of your tools and resources conveniently accessible. The height of your surfaces and chairs should be adjusted for comfort, and your space should be adequately lit. Daylight is ideal; however, rainy days and evenings make the availability of daylight inconsistent. Therefore, you will need artificial lighting as a backup and as a supplement to daylight.

The artificial lighting in my studio includes daylight-balanced fluorescents for overall illumination and a combination fluorescent and incandescent drafting lamp for task lighting. Since I work during daylight hours and at night, it is important that my artificial lighting be balanced as closely to daylight as possible. It's a matter of consistency. I want the colors in my painting to look the same whenever I choose to work.

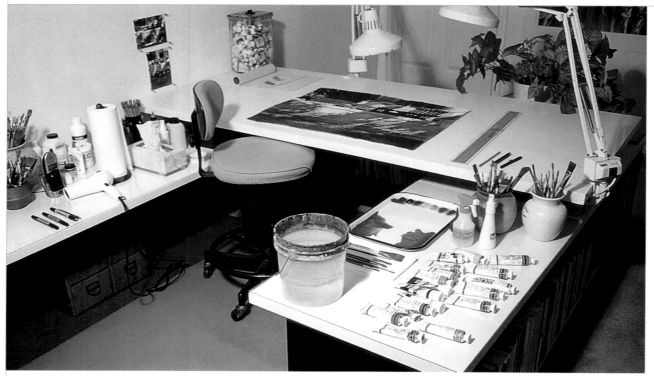

My Work Space
My primary work space consists of three hollow core doors, painted white, and arranged as illustrated. Since I am right-handed, I locate my palette, water container, spray bottles, brushes and the paints that I've selected for the current work to my right. These are the things that I need the quickest access to. At my left, I keep paper towels, tissues, and an array of tools and materials that I occasionally need. A place to sit is a matter of preference. I prefer a drafting stool, adjusted to a sit/stand height. This allows me to go back and forth from a sitting to a standing position easily. Just make your seat comfortable and convenient.

Selecting Quality Materials

Painting with improper or poor quality tools and materials is painting with a handicap. The market is replete with quality products for the artist—your time is too valuable and your work too important not to use the best quality materials you can afford. If your budget is tight, work with fewer brushes and fewer colors on your palette. Just make sure the ones you use are quality.

There are at least three good reasons why you should insist on quality products. One, the painting process is much more efficient and enjoyable when you use quality products. You should allow yourself to enjoy your work. Secondly, your inherent talent is enhanced by the use of quality products. Your growth as an artist doesn't need a handicap. You will grow faster if you're not constantly fighting with poor quality materials and inferior tools. And lastly, the longevity of your work is adversely affected by the use of poor quality materials. It is heartbreaking to see your paintings noticeably deteriorated after only a few years.

The demonstrations in this book will utilize the following quality tools and materials. These are personal choices that I currently use. They are all modestly priced and they are all subject to being replaced if I find others that are more useful. The key is to be flexible.

Shopping List

Surface
300-lb. (640gsm)
 cold-pressed
 watercolor paper
Prestretched linen
 canvas
Masonite panels
Watercolor canvas

Brushes
No. 1 and 2 liners
Nos. 4 and 8 rounds
½-inch (13mm) and
 1-inch (25mm) flats

Acrylics
Alizarin Crimson
Azo Yellow
Burnt Sienna
Cadmium Red Medium
Cadmium Yellow
Medium
Cerulean Blue
Hooker's Green
Hooker's Green Deep
Raw Umber
Ultramarine Blue
Yellow Ochre

Palette
White porcelain
 butcher tray

Additives
Flow release
Gesso
Matte medium
White absorbent ground

Miscellaneous Items
Bar of soap
Graphite pencils
Graphite transfer paper
Hair dryer
Masking fluid
Double-tipped markers
Rollerball pens (2 colors)
Scrap paper
Soft white eraser
Spray bottles and small
 syringe
Straightedge
Tracing paper
Water container
 1 gallon (3.8 liters)
 minimum
White paper towels

Paints and Palettes

There is a multitude of manufacturers marketing quality acrylic paints in both professional and student grades. If you are serious about your painting efforts, though, you should always use professional-grade products. I encourage you to experiment with a variety of professional-grade paints to determine the ones that work best for you.

When purchasing acrylic paints, there are several qualities to consider: saturation, solubility and transparency. Saturation refers to the amount of color pigment relative to other ingredients. The greater the saturation, the less paint it will take to accomplish the job. Solubility refers to the ability of a tube color to mix with water and arrive at a desired consistency. This is an especially important quality for artists who apply acrylics as transparent washes. Finally, transparency denotes the ability to see through the paint to your painting surface. You can buy transparent, semi-transparent, translucent, semi-opaque or opaque acrylics. These classifications are printed on the paint labels and can vary somewhat between brands. As a result, the manufacturer you choose may depend on your specific painting goals.

Once you've satisfied your saturation, solubility and transparency needs, you can move on to color selection. Color choices are a matter of personal preference, and like transparency and opacity, are not consistent between manufacturers. Though this inconsistency can be a problem when painting with watercolors, it's not a major concern for those painting with acrylics. Because acrylic paints are intermixable, you can use different brands of paint together on your palette without worrying about whether or not they are compatible. This flexibility allows me to use a variety of brand name products on my palette at the same time.

Selecting appropriate paints would be fruitless if you didn't have a proper palette on which to put them. A good palette is one that satisfies three basic criteria. First, it must be spacious enough that you can keep your colors separated, while providing plenty of room to prepare multiple fluid mixtures. Your palette should also be solid white, allowing the artist to see the true color of each paint mixture. And, because many acrylic paints have strong staining powers, you should choose a palette that does not stain easily. I recommend a simple porcelain butcher tray—it meets each of these requirements and serves as a great palette for the acrylic painter.

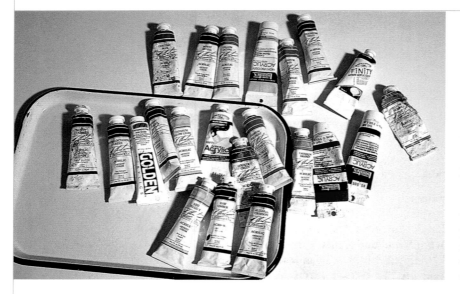

Paints and Palette
Acrylic paints, as I use them, work best on a porcelain butcher tray. Porcelain is ideal because you can easily clean dried paints from the palette and it is difficult to stain. Acrylics will stain plastic watercolor palettes. Watercolor palettes with compartments for individual colors are more difficult to keep clean as the paints dry on the palette.

Brushes

A good brush is the most important tool you can have at your disposal. A poor quality brush can take the fun out of the painting process, or worse still, ruin your composition. Securing a decent brush, then, is a necessary step in creating a successful painting. After all, when your brushes perform as intended, you are free to concentrate on the painting, not the tool.

Brushes are made from a variety of fibers and range in cost depending upon the quality of the fibers used. In general, the more precious the fiber the more costly the brush. Red sable, the most expensive brush on the market, has traditionally been a favorite with water media painters. However, the insoluble nature of dried acrylic paints makes sable brushes an impractical choice. In fact, I find that brushes with synthetic fibers are a much better choice when painting with acrylics. Not only do they perform just as well as sable brushes, but they are also much less expensive. You can also purchase synthetic/sable blends, brushes that are designed to be a practical and economic compromise between sable and synthetic brushes. As with other tools and materials, there are many good choices available, so shop around and find the type of brush that feels right to you.

Brushes also come in a variety of different shapes, each of which lends itself to performing particular functions. Three common shapes—flat, round and liner— are especially invaluable my painting process.

Flat brushes: rectangular in shape with a clean, straight edge. These brushes work well for covering large areas and for laying washes.

Round brushes: round in shape, with hair coming to a sharp, pointed tip. Round brushes are great for detailed areas, as they allow the painter to get into smaller and tighter spaces.

Liners: round in shape with long, thin fibers. Because of their shape, liners (or riggers) hold enough paint to make long, consistent strokes. They work well for calligraphy or for adding fine lines and details such as blades of grass and tree limbs.

Cleaning Your Brush
When acrylics dry on a brush, they are almost impossible to remove without damaging the brush. Even with care, dried acrylics will accumulate within the fibers and render the brush useless. This process can be delayed by frequent and thorough rinsing in clean water. At the end of every painting session, clean your brushes with mild soap and water.

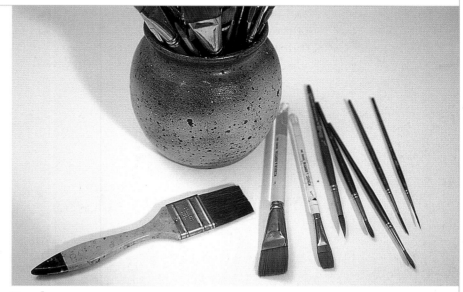

Brushes
Although I have accumulated a lot of brushes over the years, I usually work with a few favorites. My preferred brushes, pictured from left to right, are: 1-inch (25mm) and ½-inch (13mm) flats, nos. 8, 6 and 4 rounds, and nos. 2 and 1 liners. As much as 80 percent of my work is done with a 1-inch (25mm) flat. The round brushes and liners are used primarily for detail.

Supports and Additives

Once you've gathered your acrylics, brushes and a palette, you're nearly ready to execute an acrylic painting. Before you can begin, though, you will need to choose a support, or a surface on which you can paint. One of the many benefits of acrylic paints is their ability to bond to just about any porous, oil-free support. To demonstrate this versatility, the step-by-step projects in chapter four are done on three different types of supports: 300-lb. (640gsm) cold-pressed watercolor paper, gesso-primed linen canvas and gesso-primed Masonite panels. To ensure the longevity of your paintings, be sure that all of your supports are acid-free. Manufacturers of quality art materials will usually identify which products contain no acid. If a product is not marked as acid-free, don't risk purchasing it—your time and work are much too valuable to be compromised by questionable materials!

In addition to staple materials, there is a multitude of products that can make the painting process more enjoyable and efficient. These products are known as additives, or substances used to adjust the chemistry of paints. As an acrylic painter, you will find additives helpful in adjusting the handling characteristics of paint applications. In specific, you should familiarize yourself with the following list of additives, all of which are used in the chapter four demonstrations.

Gesso: used in lieu of white paint and to prime canvas and Masonite supports.

Matte medium: mixed with washes and glazes to enhance handling characteristics, especially on gesso-primed supports. It is also used as a final protective application over the finished painting.

Absorbent ground: simulates the absorbency of watercolor paper when applied to less absorbent grounds such as the gesso-primed canvas or Masonite.

Flow release: enhances the flow of fluid applications, especially on gesso-primed supports.

Masking fluid: prevents absorption of paint applications. Use this to mask areas of your painting that you wish to protect. To prevent your brush from getting damaged, apply soap to the bristles before applying masking fluid.

Supports
Because acrylics are so versatile, the choice of supports is more a personal preference than a practical issue. The majority of my paintings are done on watercolor paper because I submit many of them to watercolor exhibitions.

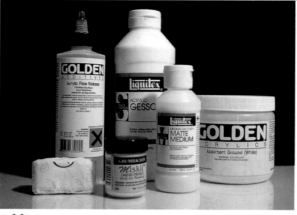

Additives
Reputable manufacturers market an array of additives that are designed to be compatible with acrylic paints. Application should always be in accordance with their recommendations.

Other Useful Tools

A painter's style and artistic personality often dictate the tools that he or she finds useful to the individual creative process. I find that many of the most useful tools aren't very expensive. Others like the camera and computer, however, represent significant investments, but can be used for numerous tasks besides creating art. The following tools are those I rely on most when painting

Spray bottle and syringe: A spray bottle is one of the least expensive but most useful tools to have at your disposal. You will find it useful in keeping paint moist on your palette and for applying moisture during application of paint. You will want to have at least two of these, giving you a choice of a fine mist or coarse mist. A small rubber syringe is useful for applying water to a mix on your palette, as little as one drop at a time.

Straightedge: When designing or composing a painting, you may find that you need a straight edge. I use a 24-inch (61cm) T-square with the T removed as my straightedge. A ruler would also do the trick.

Sketching materials: You should always keep plenty of sketching materials at your disposal, including a sketchbook, drawing pencils, and a roll of tracing paper at least as long as the narrowest dimension of the support that you will be working on.

Camera: A good 35mm SLR camera is useful in building a reference library and for maintaining a photographic record of finished works. Quality slides or photographic prints of your work are always in demand. Most exhibitions and competitions require submission of works via 35mm slides, and most gallery owners want to see 35mm slides of an artist's work before they will proceed with the interview process. Advances in digital technology and competitive pricing have made the digital camera a practical and economical tool for the artist.

Computer: Computers are also useful tools in the process of conceiving and executing your art. They are great for organizing, storing, retrieving and viewing digital images in your reference library. And, with software programs such as Adobe Photoshop, you can manipulate your digital images to create unique designs. Equally important, Internet access provides you with the opportunity to create and maintain mailing lists to stay in touch with prospective patrons, build a Web page to showcase your art and order art supplies and materials online.

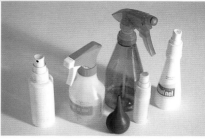

Spray Bottle and Syringe

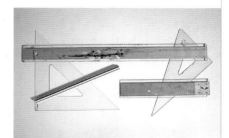

Straight Edge

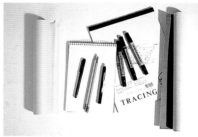

Sketching Materials

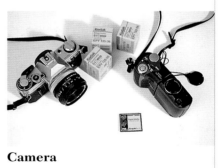

Camera

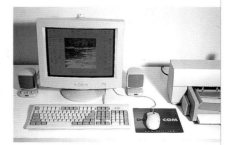

Computer

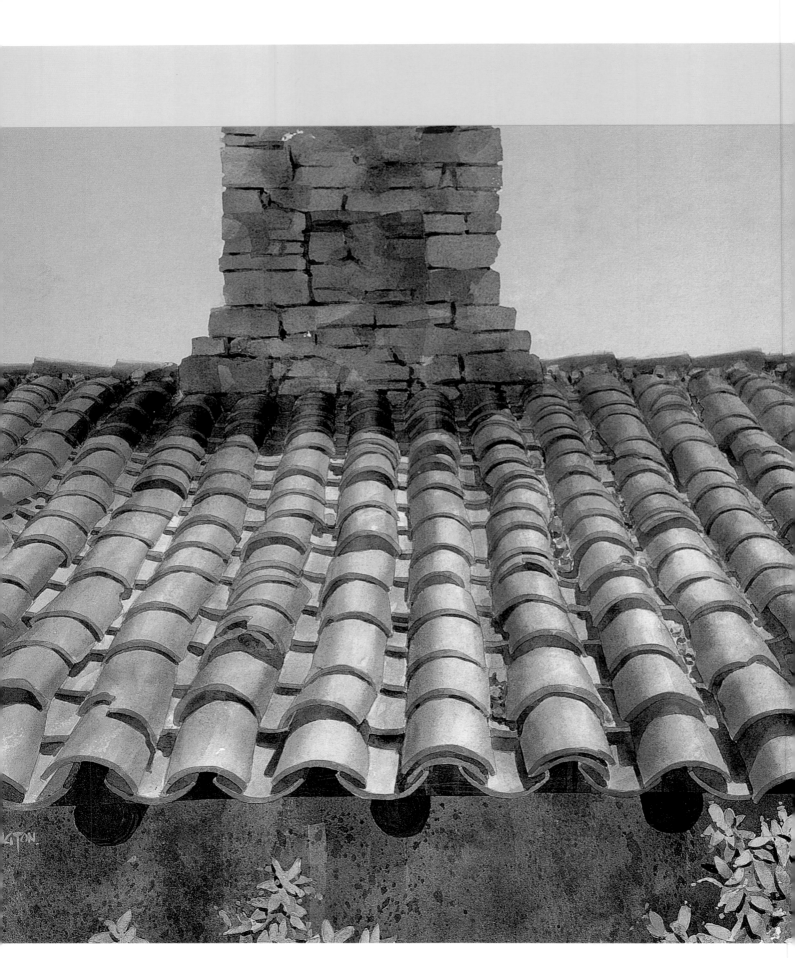

Designing a Painting

If you expect to grow and succeed as a painter, you must accept the design process as an essential prerequisite to the execution of a painting. It is in this process that the success or failure of a painting is usually determined. Remember the house builder; he can't begin cutting and putting together materials until he knows exactly what he is to build. He must come to the site with a plan, a fully developed idea influenced by his knowledge of crucial design issues. Without this plan, the results of his labor would be uncertain at best. It is only with a plan that the builder is successfully prepared to begin construction on the house. Just like the builder, you must head to your support with a determined plan. Design issues must be considered and ideas must be finalized. This chapter provides you with knowledge that enables you to carry out such tasks. You'll receive tips on how to use your photographic references to generate and develop ideas. You'll learn about important design elements and how they can impact the quality of your compositions. You'll discover the important role sketching and drawing play in the design process. And finally, you'll read about color, complete with helpful pointers that will simplify color mixing and application.

SPANISH TILE
300-lb. (640gsm) cold-pressed watercolor paper / 20" x 29" (51cm x 74cm)

Finding the Perfect Subject

One of the first obstacles a painter faces is the decision about what to paint. In more than twenty years of teaching university students, I find this decision an especially difficult hurdle for beginning painters. Second to that, many students choose difficult and complex subjects that virtually guarantee failure. Failure brings discouragement, and discouragement has caused many talented individuals to give up their pursuit of painting before they've had a chance to develop their skills. Thus, before you settle on an idea for your painting, brainstorm possibilities and choose a subject that not only excites your interests but is also plausible.

You may be asking yourself where these ideas for paintings come from. The answer to that question is usually a reflection of the individual asked. The sights, sounds and experiences of life get filtered through our own perceptions of the world around us. Things that interest and excite one person may not be of interest to another, so ideas for paintings will be unique to individuals.

However, sometimes ideas can elude the artist. The next time you come up short on ideas, try looking at your sketches or photographs for inspiration. Something prompted you to make that sketch or take that photograph in the first place. As you review, try to remember the moment. What was the inspiration that prompted the sketch or the photograph? Good ideas are inherent in these simple resources.

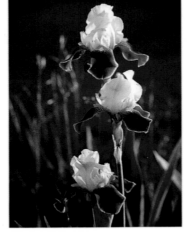

Reference Photograph
I had known for a long time that I wanted to do a painting of irises because they were special to someone dear to me. However, what I wanted to say about this subject eluded me. I studied the subject and took many photographs, but still no inspiration.

First Compositional Sketch
A closeup portrait of a single iris seemed a reasonable way to communicate the delicate beauty of the subject. But it still didn't reflect that special passion that existed between flower and gardener.

Final Compositional Sketch
After several tries it occurred to me—these flowers are like people. They have individual personalities! A special relationship does exist between them and the gardener, and perhaps between each other.

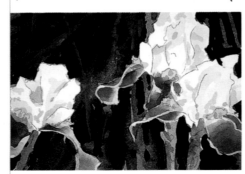

Color Sketch
Once I had an idea that I was passionate about, I created a color study sketch to prepare for the final composition. You can view the final painting, titled *Painted Ladies*, on page 38.

Discovering the Passion

I t's not enough to choose a subject that you think will look great on paper. If you want to create a successful painting, you'll need to select a subject that you can feel passionate about. Passion is an essential component of the creative process. Without it, painting is nothing more than a mechanical rendering of pretty pictures. But a painting created with passion communicates from the heart of the artist. Passion can't be hidden. It compels the artist to communicate his or her vision. In the words of St. Francis of Assisi, "He who works with his hands is a laborer. He who works with his hands and his head is a craftsman. He who works with his hands and his head and his heart is an artist." Passion alone can add that elusive component to a painting that makes it art instead of just craft.

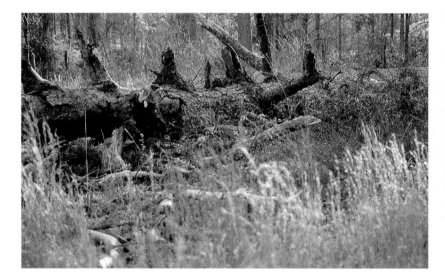

Reference Photograph
I walked past this fallen and decaying pine tree many times. Although an unlikely subject for a painting, I was drawn to it. On numerous occasions I stopped to observe it and even sketched it a couple of times. It was like the proverbial itch that I couldn't scratch. I knew that there was a painting in this old tree, but I didn't have an idea about what it should communicate.

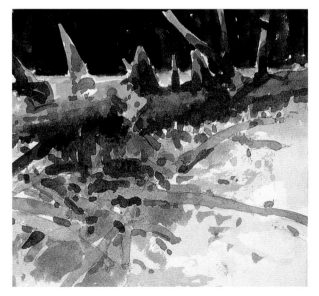

Compositional Sketch
I knew that the shapes and textures of this old tree could easily make an interesting composition, but I also felt that there was something deeper to be gleaned from the scene. This tree surely had an important story to tell, and I was determined to discover it.

I imagined that the tree had stood tall and healthy for many years, boasting beautiful foliage and strong limbs, until one day it fell victim to pine beetles. Left in a weakened state, the tree was unable to withstand the power of a windstorm and was toppled by heavy gusts. And so I discovered the tree, fallen and slowly decaying. I soon realized, however, that the tree's story didn't end here. For even though it lay dead, the tree still served a purpose—to provide nutrients to the soil from which it came. The deeper meaning was now clear—the fallen tree represented the natural cycle of life and death of all living things. But could this powerful metaphor be communicated through a painting? This was the challenge, and I gladly accepted.

Exercising the Powers of Observation

Most of us have become so desensitized to the world around us that we get little more than a cursory view of the things we see and encounter. We have trained ourselves to eliminate or ignore most of the visual input that does not have immediate value, saving us from the hassle of intellectually processing this input. Because we are not dealing with it intellectually, we are not really seeing it. As artists, we must retrain ourselves to really see, learning to observe our world as a child might observe a seashell or a butterfly for the first time.

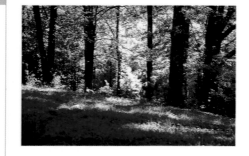

Reference Photograph
This scene showcases light and the way it illuminates portions of the woods and grassy foreground. It is about multiple shades of green and yellow against the dark tree trunks and patterns of dark and light.

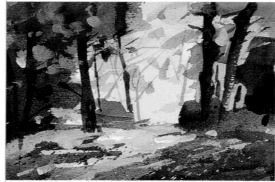

Composition I
This study is faithful to my first impression. The viewer is drawn into the woods by the spot of illuminated foliage. The trees in the middle ground are almost silhouettes serving as a visual gateway to a focal point inside the woods. This composition merely represents one way of seeing the landscape.

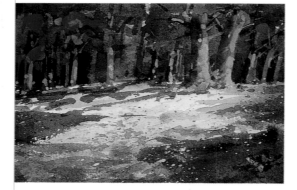

Composition II
This sketch illustrates another way of seeing the landscape. The focus is primarily on the trunks of the two dominant trees. The woods are darker, functioning more as a backdrop for the lighter tree trunks. The horizon plane is raised slightly, allowing the sunlit grassy area in the foreground to dominate the composition.

If you look closely at the reference photograph, you will see other things that could represent additional compositional options.

Look for the Essence
Try this experiment. Take a notepad, observe the subject of a prospective painting for a prolonged period of time. Record what you see. Don't quit at the first glance or the first impression. How many things do you see? Look past the details and try to really see the bigger picture. Look for the essence. What is there about this subject that is worth communicating? Then and only then are you ready to decide how to communicate what you see.

Choosing a Focal Point

Focal point is among the few design issues that have the potential to significantly affect the success factor of a painting. Simply defined, the focal point is the object or area of a painting that attracts the viewer's eye first. Similarly, it should also be the final resting place for the viewer's eye after all other elements have been scanned.

Although you can include secondary focal points within your painting, make sure that the primary focal point clearly dominates. Multiple focal points of equal interest can compete for the attention of the viewer and weaken the message that you want to communicate. Remember, you want to capture and hold the viewer's attention, not create confusion.

When placing your primary focal point, it is best to avoid the center of your composition. Such placement creates visual static and doesn't encourage eye movement within the painting. Likewise, a focal point too close to the edge of the composition can have negative effects, as it causes the eye to sense an imbalance or to exit the painting altogether. Thus, take care to keep your focal point at a healthy distance from the outer parameters of your composition as well. *Perimeter*

The three illustrations on this page show just how crucial focal point can be to the success of a composition. Although the focal point itself is the same in each of the examples, notice how poor placement in the first composition, and competing interest in the second composition, encourages your eye to exit the painting.

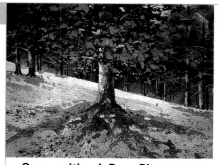

Composition I: Poor Placement
This example places the focal point in the center of the composition. Because there is no logical path for the eye to follow, it is discouraged from exploring the rest of the painting, leaving nothing but the focal point to entertain the eye. With only one element in the painting to observe, the viewer will eventually get bored and quit the painting.

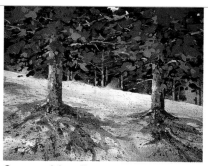

Composition II:
Competing Interests
Of the two trees in the foreground, which is the primary focal point? Because both are equally interesting, they compete for attention. Thus, the viewer is likely to be confused about what to focus on and will move to the next painting without taking time to visually explore this one.

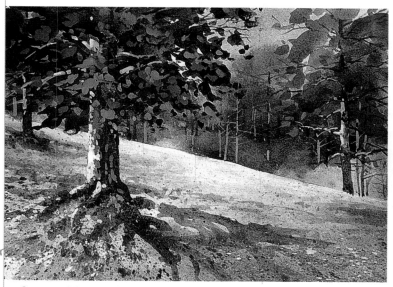

Composition III: Successful Use of Focal Point
A third option places the primary focal point, a single foreground tree, to the left of center. A secondary focal point (a smaller and less detailed tree) is placed on the right. Because of its dominance in size and detail, the viewer's eye will initially focus on the base of the primary focal point and then move to the smaller tree on the right. Once focused on the secondary focal point, the shape of the background trees and the gesture of a tree limb direct the viewer's eye back to the left toward the top of the primary focal point. The eye is encouraged to follow this triangular path as it explores the painting, ultimately coming back to the primary focal point each time. As you can see, a stronger primary focal point and a calculated visual path allow this composition to hold the viewer's interest more effectively than the first two options.

Describing Value

As a student I was told that if I got the values right, it was hard for a painting to fail. Years later, I am convinced that this is among the soundest painting advice I've ever received.

The term value refers to the relative lightness or darkness of the elements within your painting. The arrangement of light, middle and dark values is a key factor to the success of a composition. For example, the proper gradation in value will help establish a sense of depth in your paintings. That is, by overlapping shades of diminishing values, distance is suggested. To indicate depth, those objects that are farthest from the viewer should be lightest in value, while those that are closest to the viewer should be relatively darker. This is especially true in landscape paintings.

Value is also used to create the contrast necessary for grabbing the viewer's attention. In particular, strong contrasts between light and dark values tend to attract and hold the movement of the viewer's eye. Be careful that your value contrasts aren't too strong, though, as this can interrupt or destroy the unity of the composition. Likewise, be wary of value contrasts that are too subtle. A lack of value contrast between adjacent elements encourages the eye to pass over the painting without pausing.

Understanding the principles of value is an important factor in the design process, so plan your values carefully before beginning a painting.

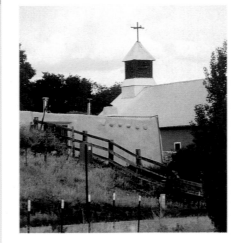

Reference Photograph
This photo was taken on a cloudy day with no hint of what lighting effects a sunny day might present. As such, it required me to take a creative look at the relative locations of sunlight, shade and shadow as a compositional issue. Small value studies are helpful in making these design decisions.

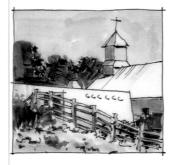

Making a Marker Sketch
Reducing the values to light, medium and dark, this marker sketch suggests one possible value arrangement. The lightest shapes are the church roof, the face of the foreground structure and the sunlit spots of grass in the foreground. Placing it in the shade darkens the visible face of the church. The dark shapes of the trees push the buildings forward, adding depth to the composition.

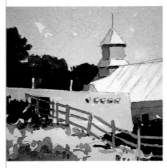

Adding Color to the Sketch
My marker sketch convinced me that I definitely wanted to make a painting out of this subject, so I did a sketch in color. Notice here that the subject is in full sunlight and is contrasted by dark middle ground trees and foreground foliage, just as it is in the marker sketch.

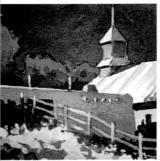

Experimenting With Different Values
I decided to examine additional value arrangements by darkening the sky and backlighting the adobe structure in the foreground. This places more emphasis on the sunlit roof and side of the church. A patch of sunlit grass in the left foreground balances the light shapes on the right. This combination of values creates a much different mood and a much stronger visual impact.

Establishing a Visual Path

The path a viewer's eye takes while examining your painting should be the result of deliberate design decisions made by you, the artist. What do you want the viewer to see and in what sequence do you want them to see it? A poorly designed visual path may result in the viewer's eyes prematurely leaving your painting or lingering too long on an unintended focal point. A well-designed visual path will always bring the viewer back to the primary focal point.

A simple admonition related to visual path is "keep the viewer's eye on your painting." Don't give the eye an easy escape route. With this advice in mind, let's look at a few examples.

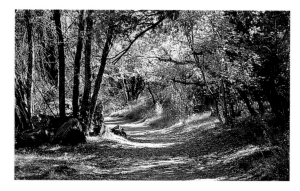

Reference Photograph
This sunlit path wanders through a parklike landscape. The path, the alternating streaks of sunlight and shadow, and the gestures made by the tree trunks and limbs all work together to keep the viewer's eye on the painting. They also reinforce the focus down the path into the woods.

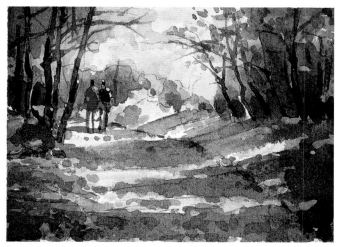

Composition I: Strong Visual Path
The addition of human figures facing into the woods further heightens the mystery that draws the eye down the path to the intended focal point. This composition does a good job of keeping the eye movement within the boundaries of the image. It does so by stopping the viewer's eyes at the boundaries and redirecting them back into the image where the viewer will again find the focal point. The composition has been changed slightly to add a bit more weight to the foreground and to shift the focal point slightly to the left.

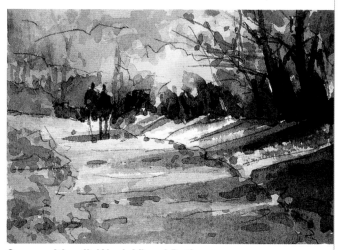

Composition II: Weak Visual Path
By eliminating the dark tree mass on the left and some of the foreground shadows, the visual path is weakened considerably. The eye now tends to leave the image at the left side and tempts the viewer to move onto the next painting. Try identifying and testing the visual path on a few of your favorite paintings. Did your eye go directly to a focal point? After moving off the focal point, what did the artist do to turn your eye and bring it back to the focal point?

Establishing a Visual Path Continued

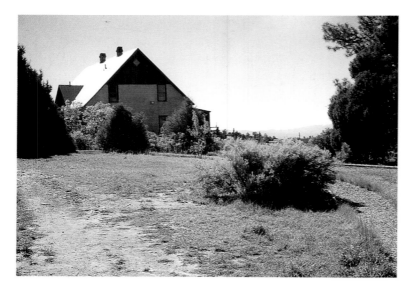

Reference Photograph
It is always satisfying when a photographic reference contains all of the elements necessary for a good composition. The house wants to be the subject and should be the undisputed focal point in the painting. We will look at two alternative compositions based on this photograph: one that has a poorly designed visual path and one with a well-designed visual path.

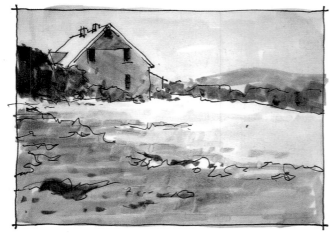

Composition I: Weak Visual Path
Eliminate the tree mass at the right of the photograph and the ranch house still immediately draws the eye. It is unquestionably the focal point. However, as the eye moves to the right, it tends to leave the image, making it more difficult to keep the viewer's attention. This is not a well-designed visual path.

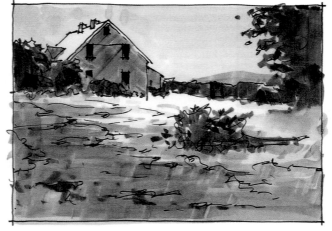

Composition II: Strong Visual Path
Restore the tree mass to the right side of the composition and the eye movement is noticeably halted and even directed back toward the focal point by the gestures of the tree foliage. The addition of the dark shrubbery in the lower center of the composition gives the eye a third stopping place as it moves around a particular path. This triangular path does a better job of keeping the eye movement contained within the image.

Sketching Before Painting

Drawing is at the very heart of conceiving, designing and executing a painting. It begins when you sketch to record ideas or impressions of the fleeting sights around you, and continues until you have successfully applied the last brushstroke to your painting. Thus, drawing skills are prerequisites for well-designed and well-executed paintings.

Much of the drawing that you do in preparation for painting can be defined as sketching. By definition, sketches are quickly executed without concern for detail. Although the method and the medium may vary, the purpose of sketching is to help you visualize and test ideas before investing time in detailed drawing and painting. Below I have identified four types of sketches that I use frequently in the drawing process, each of which serves its own distinct purpose.

The idea sketch is a small sketch executed quickly without any attention to detail. Its purpose is to capture just enough information about the subject to stimulate your memory at a later date. My idea sketches are generally no bigger than 2" (5cm) wide and take roughly two minutes to draw.

If interest in the subject persists, you can make a detail sketch. These sketches include basic detail and serve as an outlet to explore design issues like visual path and value arrangement. They are usually no more than 6" (15cm) wide and can be completed with a no. 2 graphite pencil.

A marker sketch allows you to study alternative value arrangements. Keep these studies simple and quick by using only three shades of gray markers and a black roller ball pen. Detail is not an objective in these sketches.

As a final study before committing to a full-scale drawing and painting, I complete a painted sketch on scrap watercolor paper to experiment with color selections. Resolving color issues at this stage will give you more confidence as you begin painting.

Idea Sketch
Many paintings have their beginning in a hastily executed idea sketch on a notepad or the back of an envelope.

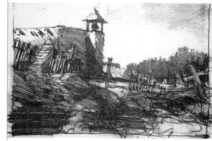

Detailed Sketch
Larger and more detailed than an idea sketch, detail sketches explore compositional issues such as value relationships.

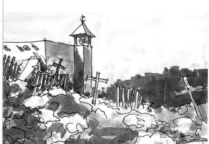

Marker Sketch
Use marker sketches to experiment with alternate value arrangements. I recommend Prismacolor markers for the job.

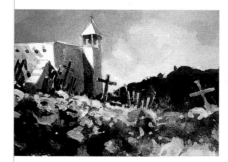

Painted Sketch
Painted sketches can be completed on scrap watercolor paper and allow you to explore color and compositional possibilities.

Draw, Draw, Draw! ✓

Drawing is a requirement for painters. To be successful he or she must be comfortable and competent with drawing techniques and medium sufficient to support the conception, design and execution of their painted works. Style and medium are not important as long as they lead to a successful conclusion. As Degas said, "Make a drawing, begin it again, trace it; begin it again and trace it again." Sounds like good advice for those of us who aspire to be artists—draw, draw, draw!

Dividing Your Paper Space

We often use the word composition to refer to a work of art. More specifically, though, composition is the placement or arrangement of design elements within a painting. To develop your sketches into successful paintings, you must position the parts and elements of your subject within specified boundaries on your sheet of paper or canvas. This does not happen serendipitously. Knowing how to divide your paper space, then, is a prerequisite for creating a successful composition.

Many methods of dividing paper space focus strongly on the proper placement of the focal point and the visual path that supports it. Of all the methods available, I find the Rule of Thirds to be the simplest and most efficient way to divide paper space. Not only does this method work well for planning prospective compositions, but it also serves as a tool for analyzing the placement of elements in finished paintings.

Applying the Rule of Thirds to your sketches and compositions is easy. Simply divide the paper space into thirds, vertically and then horizontally. The three columns crossed with three rows create nine quadrants on your paper. The space surrounding the four major intersections (each corner of the center quadrant) is an ideal location for the primary focal point. The placement of other components should relate to this point, creating a comfortable visual path that eventually leads the eye back to the primary focus. Following this simple method brings you one step closer to creating successful paintings.

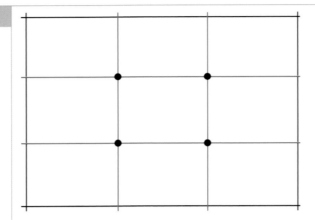

Making the Grid
To make a Rule of Thirds grid, simply divide your paper space into thirds vertically and then horizontally, creating nine quadrants. If you don't want the lines on your sketch or photograph, apply them to a transparent overlay or draw lightly enough that you can erase pencil marks. The important thing is that you see the division of space, especially the points of intersection, which serve as strategic locations for focal points.

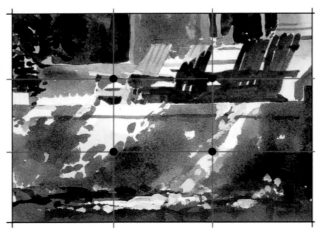

Analyzing a Compositional Study
This small color sketch was executed as a compositional study for a much larger painting. By applying a Rule of Thirds grid overlay, one can see that the focal point falls comfortably near the intersection in the upper right-hand quadrant. Other shapes, such as shadows, patches of sunlight and foliage help create a visual path that keeps the viewer's eye moving within the boundaries of the painting.

Exploring Possibilities
The four boundaries inherent in your camera viewfinder make it a great tool for exploring compositional possibilities. Photographs from your reference library can usually present new compositional ideas when you do a bit of creative cropping. Take four sheets of white paper and use them to define new boundaries, masking out all of the photograph except what you want to view as a possible new composition.

Dividing Your Paper Space Continued

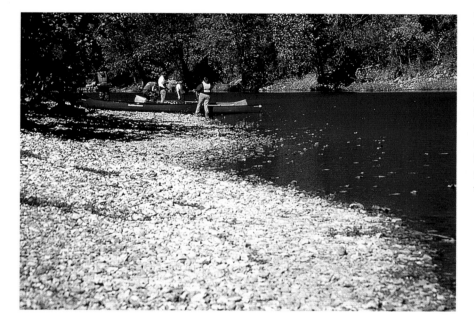

Reference Photograph
After a bit of practice, you will begin to take photographs that you plan to use as references with the Rule of Thirds in mind. The scene depicted in this picture is an example. All of the elements necessary to create a strong composition are already present, with the canoes and people in the upper left-hand corner serving as an obvious focal point and the water providing a strong visual path.

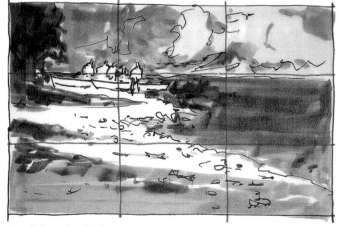

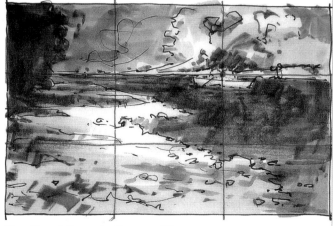

Applying the Rule
The Rule of Thirds grid drawn over this marker sketch quickly confirms a strong focal point at the intersection of the grid lines in the upper left-hand quadrant. The addition of foreground shadows completes the composition. They connect with the dark water and the background foliage to create a comfortable visual path that brings the viewer's eye back to the focal point.

Creating Alternate Compositions
Compositional possibilities are limitless when using the Rule of Thirds. By simply shifting the focal point to another intersection on the grid you can create an entirely different composition! For instance, eliminating the existing canoes from the reference photograph and adding a canoe paddled by two occupants shifts the primary focal point to the upper right-hand quadrant of the image.

Transferring Drawings to Your Support

Once you have resolved design and composition issues through a series of sketches and studies, you'll want to make a full-scale drawing that can be transferred directly to your support. If your composition is simple enough, it can be drawn directly on the support itself. However, in many cases your drawing will be so complex that it is best to resolve all design issues on tracing paper first. Once you're finished, you can then transfer the drawing to your support using graphite transfer paper. This process allows you to make erasures and other alterations to the drawing without making a mess on your support. Remember, pencil lines will usually be visible through transparent washes in your painting, and erasures will often blemish the surface of your support so that it does not absorb paint uniformly.

Illustrations on this page show you how you can use the Rule of Thirds to assist in the transposition of your small sketches and compositional studies to a full-scale drawing. I highly recommend this method of enlarging your small sketches. Projecting your composition onto your painting surface by "eyeballing" it may sound simple enough. But a drawing that looks good in a small sketch often fails to successfully translate to a larger format, as it is difficult to adjust the proportion and size of the shapes to suit a larger scale. Using the Rule of Thirds grid is an efficient way to eliminate such obstacles and save you time.

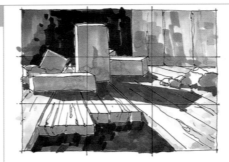

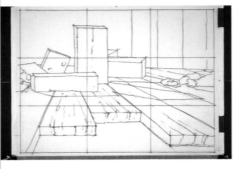

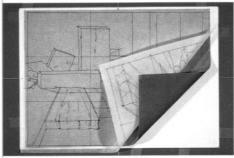

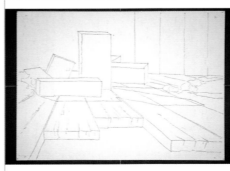

Preparing the Sketch
The first step in creating a full-scale drawing to transfer to your support is the accurate transposition of the information in your sketch to a larger format. The Rule of Thirds comes in particularly handy for this task. I overlaid my sketch with the 3" x 3" (8cm x 8cm) grid, dividing my composition into nine quadrants.

Creating a Full-Scale Drawing
Next, I drew the boundaries of the full-scale drawing on a sheet of tracing paper and divided the space into nine quadrants. Referring to my sketch, I placed the shapes in each quadrant of the sketch in the corresponding quadrants of the tracing paper. If the size or detail of your drawing dictates, you can further subdivide the grid into 6" x 6" (15cm x 15cm) or 12" x 12" (30cm x 30cm) quadrants.

Transferring the Drawing
Once I finished drawing, I transferred the composition to my support. To do this, place a sheet of graphite transfer paper over your chosen support. Then place your finished drawing over the transfer paper and secure it at the corners with masking tape. Using a roller ball or ballpoint pen, trace the drawing with a firm stroke. This will transfer the lines to your support.

The Final Result
This process produces a clean graphite drawing on your paper or canvas support. After removing the transfer paper, you may add to or alter the drawing with a graphite pencil until you feel confident with the composition. Then you're ready to start painting!

Drawing Marks
Using transparent media means that any drawing marks made directly on your paper or canvas will likely be seen through the paint in the lighter passages of the painting. Most transparent media painters, including watercolorists, do not object to this because it is a natural part of the process.

Working with Color

I n addition to the three essential design issues discussed earlier, color plays a key role in the success of your paintings. Achieving accurate color in most compositions requires the painter to mix together two or more colors. As such, a basic understanding of color theory benefits artists of all skill levels.

Working with color can be intimidating, even to the most experienced painter, and the application of its principles to the painting process can prove a bigger challenge still. Adding to this the fact that colors are not consistent between manufacturers only complicates the process further. Take Burnt Sienna, for example. In looking at four or five of the leading brands, you're likely to find that no two are identical in color or mixing characteristics. This can be frustrating and even confusing to the beginning painter. A simplified approach to color mixing, then, is often the best solution for the beginning artist. The "basic mix," as I call it, serves this purpose, functioning as a simple palette for any painting. This mix consists of Ultramarine Blue and Burnt Sienna. By simply combining these two colors, you can achieve a wide variety of neutral colors to use in your paintings. Other colors can be added as needed for specific application. (See the shopping list on page 13 for a list of additional colors to keep on hand.)

The Basic Mix
My basic mix combines Ultramarine Blue and Burnt Sienna. Between these two colors you can mix an astonishing variety of browns and grays ranging from warm to cool. Experimentation will determine which brands best satisfy your color mixing needs.

Painting With the Basic Mix
This detail is from a painting called *Stone Carving*. The entire painting was done with nothing more than the basic mix (after a very light glaze of Yellow Ochre was applied to the paper to enhance the sunlit effect). Most observers would consider it a full-color painting.

Adding Color to the Basic Mix
Because of the neutral nature of the basic mix, when one or two additional colors are added, they become much more important to the composition than they might be in a painting with several brighter colors. In this detail, the turquoise was mixed by adding a small amount of Hooker's Green to the same Ultramarine Blue used in the basic mix. Note how the turquoise comes to life next to the neutral basic mix.

Using Color for Emphasis

Although I enjoy doing paintings occasionally with nothing more than the basic mix of Burnt Sienna and Ultramarine Blue, I readily acknowledge that many artists want more color in their paintings. My recommendation is that other colors be added to this palette one at a time on an as-needed basis to create specific emphasis in your painting. The intent of this simplistic approach to color isn't to minimize the importance of learning and using everything you can about color and color theory. It is only suggested as a safe starting place for beginning painters and an interesting experiment for experienced painters. The two examples on this page illustrate ways you can establish strong color emphasis without applying complicated techniques or strategies.

The first example employs only the basic mix. You can achieve emphasis in this way by varying the intensity of either Burnt Sienna or Ultramarine Blue, or one of the colors mixed from these two staples. The more intense the color, the more the viewer's eye will be drawn to it. The second example involves the use of several additional colors. Simply choose two complements and place them adjacent to each other. Complements by nature emphasize each other, but they especially stand out when set against the basic mix.

Using the Basic Mix Alone
This detail from *Stone Carving* includes a part of the painting where the Burnt Sienna has been used without mixing in order to emphasize specific details. In this case, when Burnt Sienna is set against the neutral mix, it appears quite colorful and draws the attention of the viewer. The same would be true if the Ultramarine Blue was set against the neutral background. Remember that the basic mix starts with Ultramarine Blue and Burnt Sienna—both very strong colors. Combined with the wide range of neutrals that can be mixed between these two colors, you can create a pretty colorful painting.

Adding Complements to Emphasize Elements
This detail from the painting *Taliesin* adds Hooker's Green and Alizarin Crimson to the basic palette. They make a strong statement for two reasons: They are set against the neutral mix which tends to emphasize them, and crimson (red) and green are complementary colors. By placing them together, they draw attention to themselves and to each other. Using this approach, you can try adding other colors as the need arises.

Subduing Color Intensity

Acrylic colors tend to be more intense than the same colors in watercolors or oils. This can be considered an advantage or a disadvantage, depending on the needs or preferences of the individual artist. The intensity of acrylic colors may be easily subdued by mixing a bit of the color's complement during the application process or as a glaze after the first application has dried. Complement refers to the color located directly across from the subject color on the color wheel. For example, green is directly opposite red on the color wheel. Mixing green and red will result in a neutral gray. The two colors neutralize each other. An intense color can also be subdued by mixing it with the basic gray mix. To demonstrate, we will try both methods.

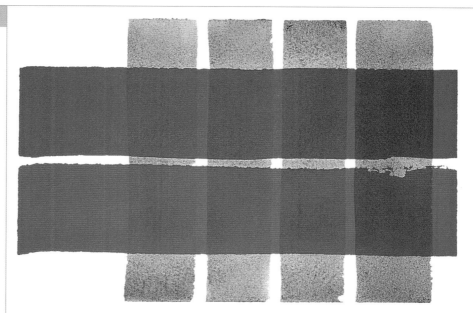

Using the Basic Mix
Stripes of Cadmium Red Medium and Cadmium Red Light are glazed with four variations of the basic mix. The red is neutralized and leans toward warm or cool, depending on the mix.

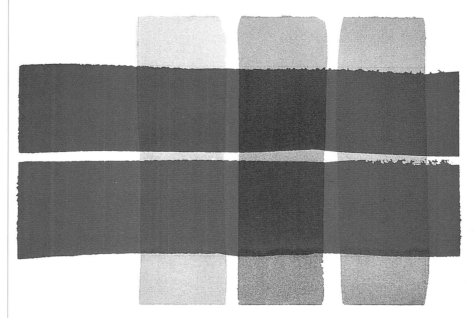

Using a Complement
Here, the same red stripes are glazed with a light shade of Hooker's Green and a green mixed from Azo Yellow and Ultramarine Blue. Try this experiment on a few of your favorite colors.

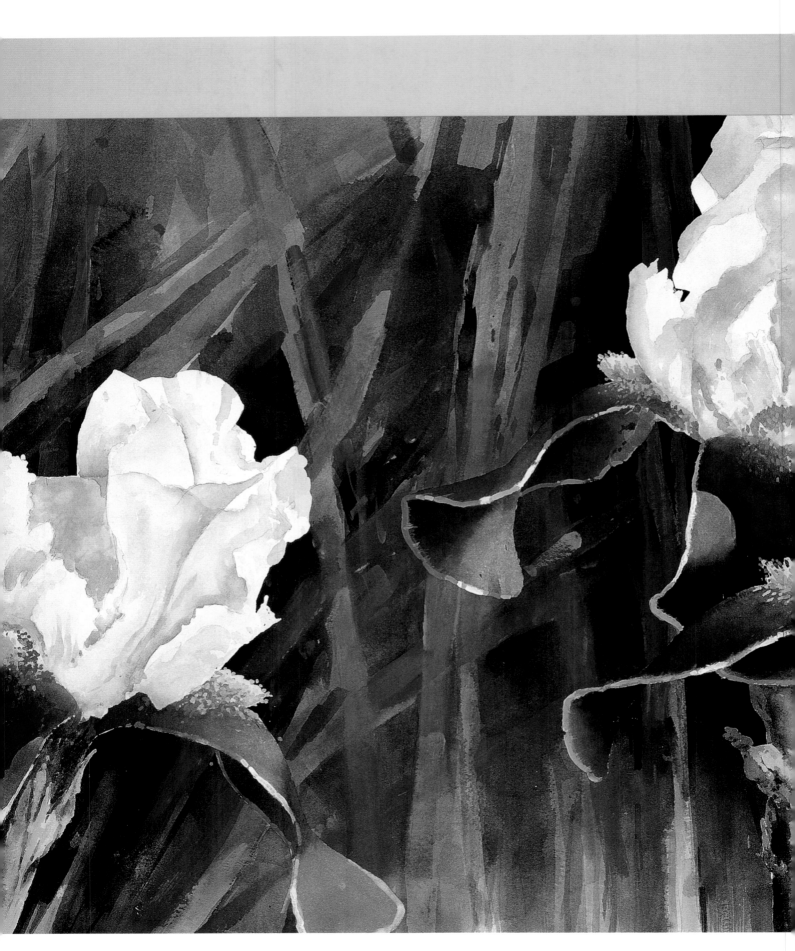

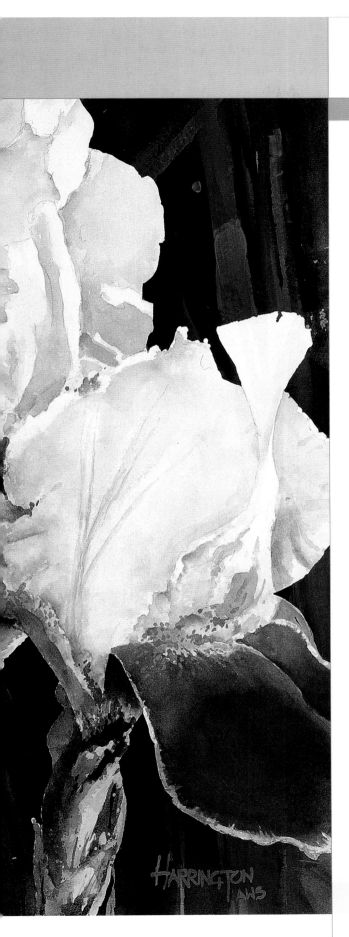

Technique Exercises

Technique refers to the manner in which you handle the fundamentals as you complete a task. If the builders in our analogy approached the task of constructing a house without first mastering relevant technical skills, they would have very little hope of success. As a painter, you too must master those skills that are important to your trade. In this chapter you will complete a series of exercises that provide you with the practice essential for developing these skills, improving your chances of producing successful paintings. You will learn methods that enable you to control the medium, such as keeping your paint moist while working and avoiding mud when mixing color. You will also master applications that help you create interesting textures and control edges. Remember, the objective of these exercises is to learn techniques. They need not represent well-designed compositions to be effective. However, they do represent skills that you will need to successfully complete the demonstrations in chapter four, so the more practice, the better!

PAINTED LADIES
300-lb. (640gsm) cold-pressed watercolor paper / 21" x 29" (53cm x 74cm)

Keeping Paint Moist

Materials

Acrylic paints
Paper towels
Spray bottle
Water container and
 clean water
White porcelain
 butcher tray

The first technique you'll need to learn to ensure success with your acrylics is how to keep your paints moist. When acrylic paints dry, they are no longer water-soluble. This is one of the attributes of acrylics that makes it possible to lay multiple, consecutive glazes without worrying about lifting paints from previous applications. Such a characteristic frees the acrylic painter from the fragility of watercolor or gouache. However, acrylics do dry rather quickly and once they lose their solubility they are no longer usable. This can present a challenge to painters accustomed to other mediums, and they may find their paints drying on their palettes before they've finished using them. Fortunately, though, there are ways to circumvent what could otherwise be a dilemma to the new acrylic painter.

The following exercise illustrates a simple technique that you can utilize to keep the paints on your palette moist long enough for you to use them. It also comes in handy for keeping mixes that you prepare on your palette fluid as long as possible, giving you ample time to apply them.

1 Prepare the Paper Towel

Fold a paper towel lengthwise, then fold again. If you have folded correctly, you will have a four-ply fold that is approximately 11" x 3" (28cm x 8cm). Cut or tear the length of the folded towel to match the width of your palette.

2 Wet the Paper Towel

Holding the folded towel as indicated, dip it into your clean water container, and let it drain for a few seconds.

3 Dress Your Palette and Place Paints

Place the wet towel at the end of your palette and squeeze your paints onto the towel as shown. Your palette is now ready for use. The wet towel will keep the acrylics moist for hours. Occasionally misting with your spray bottle will also help the paints retain moisture.

As paint mixes dry on the palette, mist with your spray bottle and wipe the palette clean with a fresh paper towel.

Avoiding Mud When Mixing

Another technique you'll want to familiarize yourself with before you begin painting is how to avoid mud created by overworked mixes. The dreaded *mud* familiar to watercolor painters is almost always the result of overmixing colors on the palette before painting. This problem can easily be avoided by allowing your colors to mix on the support after they've been applied instead of premixing them on your palette. Still, you'll need to be careful not to overwork your brush when applying the colors to your support, or you'll end up with the same dull, flat and muddy mixture you were trying to avoid in the first place.

Follow the simple two-step exercise below to help you avoid mud when mixing your colors.

Materials

Surface
300-lb. (640gsm)
cold-pressed
watercolor paper

Brushes
1-inch (25mm) flat

Acrylics
Burnt Sienna
Ultramarine Blue

Other Supplies
Paper towels
Water container
and clean water
White porcelain
butcher tray

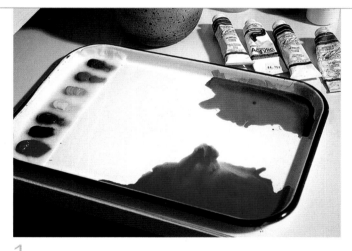

1 Prepare Colors

First prepare your palette following the instructions on page 40. Once your palette is ready, mix water and paints on your palette, creating individual puddles of Ultramarine Blue and Burnt Sienna. Do not combine the colors on your palette; rather, load your 1-inch (25mm) flat with both colors, dipping it consecutively into the separate puddles.

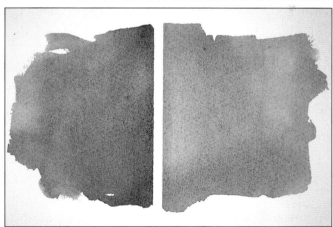

2 Apply Colors to Support

With as few strokes as possible, apply the paint on the loaded brush to the left side of your paper, then lift the brush. Don't overwork. Let the colors mix themselves while the application is still wet.

To illustrate the importance of allowing colors to mix on your support, thoroughly mix the two puddles of Ultramarine Blue and Burnt Sienna on your palette, then apply the mix to the right side of the same sheet of paper. Compare the two. The mix on the right looks flat and dead while the one on the left has life and variety. Repeat this experiment with some of your favorite color mixes.

Creating Edges

Materials

Surface
300-lb. (640gsm)
cold-pressed
watercolor paper

Brushes
1-inch (25mm) flat

Acrylics
Hooker's Green

Other Supplies
Spray bottle

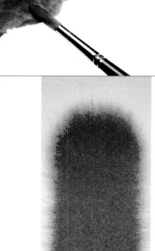

Although edges have significant design implications, we will deal with them here only as techniques that need to be mastered. Most realistic paintings require you to use a variety of edges, both hard and soft, to accurately render the subject at hand. As you'll soon see, hard edges are created by applying strokes of paint to a dry support, known in the watercolor world as painting wet-on-dry. Conversely, soft edges are created by applying color to a wet or damp surface, or painting wet-into-wet.

The exercises on this page serve as a quick reference guide to creating both types of edges. You will also learn a useful trick for altering existing hard edges to create a more textured and spontaneous look. Be warned, though: This method requires a good deal of monitoring and practice.

Create Soft Edges
Moisten your paper with your brush and some clean water. Using the same brush, apply a stroke of Hooker's Green to your paper. Notice the edges will continue to spread until the paper is dry. The amount of spreading varies depending on the texture of your paper and the amount of water used to moisten the paper.

Create Hard Edges
Load your brush with Hooker's Green and apply to dry paper. Allow the paint to dry, noting the hard, crisp edges of the stroke. If you want to maintain hard edges when laying consecutive, fluid washes, be sure to mask the edges (see page 44).

Create Textured Edges
Apply a stroke of Hooker's Green to dry paper. Then, mist the surface using your spray bottle, softening certain areas and encouraging the paint to spread in spontaneous directions. Note that when using this technique in actual paintings, you should always monitor the spreading paint with a clean, moist brush. The results can be somewhat unpredictable, and you may need to control the spreading.

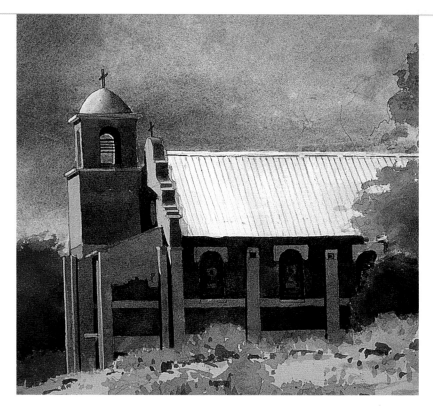

Hard Edges in a Completed Painting

The hard edges in this detail from *Church at Lamy* were attained by applying paint to dry watercolor paper. Some of these edges (particularly those of the building closest to the sky) were masked before I laid in the sky to prevent them from softening or spreading. You will learn how to use masking fluid to help you maintain crisp, clean edges on the next page.

Soft and Textured Edges

Another detail from the same painting illustrates the use of both soft and textured edges. These were created by painting wet-into-wet and using the spray bottle technique to alter existing hard edges. Notice these techniques are great for creating the soft and natural edges in the grasses and foliage.

Using Masking Fluid

Materials

Surface
300-lb. (640gsm)
 cold-pressed
 watercolor paper

Brushes
No. 4 round
1-inch (25mm) flat

Acrylics
Burnt Sienna
Cerulean Blue
Raw Umber
Ultramarine Blue
Yellow Ocher

Other Supplies
Bar of soap
Masking Fluid

The white of the painting ground, either untouched or visible through a transparent application of paint, plays an important role in watercolor painting. This is because white paint is seldom included on the palette. Instead, painters preserve the white of the ground where white or very light passages are desired. Painting around these whites, though, can prove difficult, especially if the areas to be preserved are small or detailed. In such instances it's only logical to turn to masking fluid to protect passages. However, if you're painting with watercolors, masking fluid can harm previous applications of paint and even lift out pigment. The acrylic painter, on the other hand, doesn't have to worry about such limitations. Since acrylics are no longer water-soluble after they dry, you can apply masking fluid to an already painted surface without fear of lifting previous applications. This is just another of the many reasons to use acrylics to create your watercolor-like paintings.

Although you can use masking fluid with virtually no worries when painting with acrylics, you still need to practice applying it to your ground. To demonstrate the usefulness of masking in transparent mediums, this exercise presents you with an intricate subject that is painted with multiple layers. Without masking, painting around the complex shapes and edges would get very tedious.

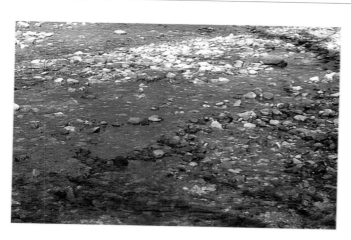

Reference Photograph
Use this photo of a gravel bar at the edge of a river to complete this exercise. By using masking fluid, consecutive washes can be applied over the previous one without concern for losing shapes and edges that need to be preserved. Focus on the transition between dry gravel and the water. As the water gets deeper, the gravel becomes less visible. Take your time and have fun with it.

1 Complete Initial Drawing and Apply Masking Fluid
Based on the reference photograph, draw enough of your subject that you know where the first layers of gravel and water will be located. Prepare your no. 4 round by wetting and lathering with soap (note that the soap is for the protection of the brush and has nothing to do with the effectiveness of the masking fluid). Remove the soap from the exterior of the brush by wiping it on the palm of your hand. Using this brush, apply masking fluid to the first layer of gravel. Rinse the soap and masking fluid from your brush between steps.

2 Lay First Washes of Color

Using your 1-inch (25mm) flat, apply washes of Raw Umber to the gravel area. This will represent the layer of gravel that is wet or partially submerged. Apply multiple thin washes of Cerulean Blue to begin shaping the deeper pools of water. After you are satisfied with this layer, apply masking fluid to a second layer of gravel.

3 Begin Second Layer

Repeat step 2, using the same brush and colors to apply washes to a second, slightly darker layer of gravel. The deeper the gravel is submerged in the water, the darker and bluer it appears. Once finished, apply masking fluid to a third layer of gravel.

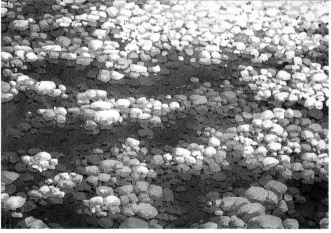

4 Darken Deeply Submerged Gravel

Apply appropriate washes to darken the deepest layer of submerged gravel and water using the same colors from previous steps. Repeat until you have layered the gravel and water to your satisfaction. Remove all masking fluid from the painting. Rub with your index finger to start the removal. As the masking fluid is removed, roll it into a ball and use it like an eraser to continue the removal.

5 Add Finishes Touches

Using your no. 4 round and Yellow Ochre, add shape and highlights to gravel. Lay a wash of Burnt Sienna and Ultramarine Blue to selected gravel to provide color variety and unity to the finished painting.

Using Additives

Materials

Surface
300-lb. (640gsm)
cold-pressed
watercolor paper

Brushes
1-inch (25mm) flat

Acrylics
Ultramarine Blue

Other Supplies
Flow release
Gesso
Matte medium

Masking fluid isn't the only supplemental material you'll find helpful when using acrylic paints. You'll also find several additives, or substances designed to enhance your paint applications, rather useful. There is an array of acrylic additives available on the market, each of which targets specific needs. However, since this book focuses on using acrylics to emulate watercolor, we'll focus on two additives that assist with transparent applications: matte medium and flow release.

Matte medium is a milky white substance that dries transparent if applied properly. Adding matte medium to your water/paint mix increases the viscosity of the mix without compromising the transparency of the paint application. Flow release is a clear, colorless liquid that enhances the flow of your water/paint mix. Because concentrated flow release remains tacky when dry, I recommend using only small amounts in your water/paint mix. To do otherwise may compromise the durability of your finished painting and prevent the acrylics from drying properly.

If painting on quality watercolor paper, you may find these products unnecessary; however, they are imperative when your painting support is less absorbent. This is the case with any support that has been primed with gesso or in instances where you want to paint transparent applications over passages where opaques have already been applied.

Since one or both of these products are used in several step-by-step demonstrations in chapter four, take the time to complete the exercises on page 47. The matte medium exercise illustrates the benefits of using a mixture of water and matte medium when painting on primed surfaces, while the flow release exercise shows you how to properly apply a mixture of color and flow release and how to create interesting texture using this same mixture. Both exercises are useful, as practice will make you more comfortable using these products and show you how to get desired results.

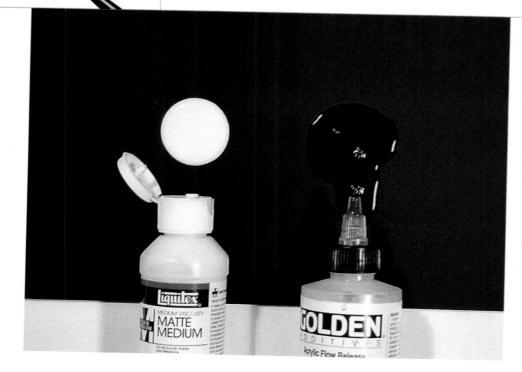

Familiarize Yourself With the Products
Before you begin experimenting with matte medium and flow release, squeeze a bit of each onto a dark nonabsorbent surface and let them dry. Observe their physical characteristics in both their wet and dry states. Remember, though: Always exercise caution when using these products and follow the manufacturer's recommendations. The product labels will specify proper use and will usually indicate the consequences of noncompliance.

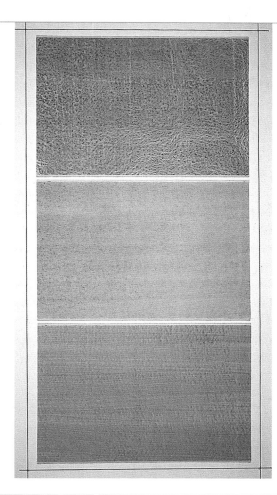

1 Lay Color Diluted with Water Only

Using your 1-inch (25mm) flat, prime your paper with three coats of gesso. Once the gesso is dry, divide your paper into three separate sections. Dilute Ultramarine Blue with water only and apply this mixture to the first section of your paper. Notice the mix does not adhere to the surface consistently and pigment settles into the indentations on the paper surface.

2 Lay Color Diluted with Water and Matte Medium

For the second section, mix your wash with one-half water and one-half matte medium. Notice the resulting increase in viscosity makes the mixture adhere to the ground more evenly. It resists settling into the indentations in the paper texture and is more smooth and consistent in appearance.

3 Lay Color Diluted with Matte Medium Only

In the third section apply a mixture of Ultramarine Blue diluted with matte medium only. (Note: Since your brush is wet, there will be a small amount of water in the mix.) This mix is so viscous that the brushstrokes are still evident even after the wash dries.

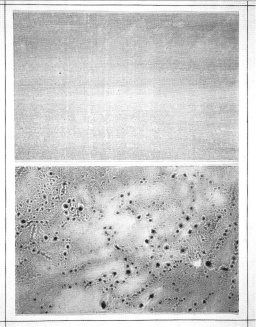

1 Apply Color and Flow Release Mixture

On another piece of gesso-primed watercolor paper divided into two sections, prepare and apply the same paint and water mixture that you used in the first section of the last exercise. Then, add two or three drops of flow release to the mix. Apply a consistent wash with your 1-inch (25mm) flat. After drying, the wash should be similar in appearance to the second section of the matte medium exercise.

2 Create Texture with Color and Flow Release Mixture

Apply another wash of the same color/flow release mixture to the second section of your paper. This time though, vigorously work your mixture directly on the ground with random, back-and-forth brushstrokes. This results in a foaming action. Let the wash dry and observe. Although somewhat unpredictable, the resulting texture has some interesting possibilities.

Glazing Transparents Over Opaques

Another technique that you will use frequently in chapter four, as well as when painting with acrylics in general, is applying transparent washes over existing opaque passages. This gives you the freedom to execute some or all of a painting using opaques and then apply multiple transparent glazes over these passages to make them transparent in appearance.

Because opaques can always be glazed over with transparent washes when using acrylics, the artist has room to make errors. In particular, if you want to remove an object from your painting, simply cover it with opaques and then paint over the area. Likewise, you can add objects to already painted areas by painting the silhouette of the object with gesso and then glazing it with transparent washes to add definition. Simply put, this technique allows you to achieve the aesthetic of a transparent watercolor without having to deal with some of watercolor's inherent limitations, thus representing another significant advantage to using acrylics.

The following exercise demonstrates how you can use this technique to make corrections to a composition, adding objects that weren't initially intended to appear in the painting. If you take your time and do this correctly, the viewer will never suspect that the additional objects weren't a part of your original painting.

1 **Paint Stucco Wall**
Prime your paper with gesso using your 1-inch (25mm) flat. Then, paint a simple stucco wall using the same brush and various mixtures of Ultramarine Blue and Burnt Sienna diluted with a 50/50 mix of water and matte medium. Add some subtle texture using the splatter technique demonstrated on page 54. Let this dry.

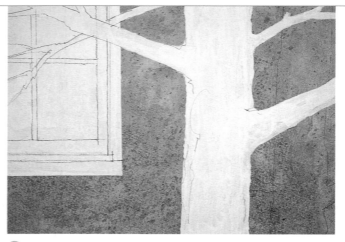

2 **Add New Objects Using Gesso**
Now add a window and tree to the composition, sketching the new objects over the stucco wall. Since the white of your initial ground has been lost under the stucco application, paint the new shapes with white gesso using your no. 8 round. To avoid brush marks in the dried gesso applications, thin your mixture with a bit of water. Apply several applications, repeating until the window and tree shapes are white again.

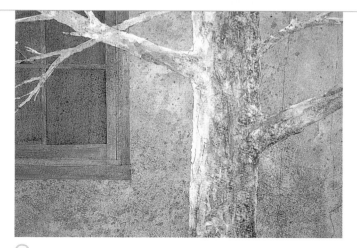

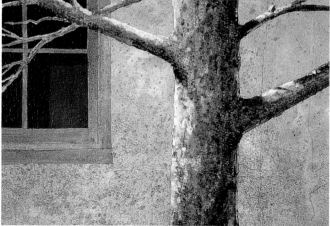

3 Lay Initial Transparent Washes

Using your 1-inch (25mm) flat, lay several transparent washes of Ultramarine Blue and Burnt Sienna diluted with a 50/50 mixture of water and matte medium over the tree. Then lay several washes of the same mixture with more blue added over the window. Be sure to make the panes of glass darker than the frame. Let your paper dry.

4 Continue Developing Tree and Window

Continue building up the texture and values of the new objects as if they were part of the initial painting. If you are successful, the viewer will not suspect that they are corrective additions. Since the gesso ground is not as absorbent as unprimed watercolor paper, it may take multiple washes to accomplish your aesthetic objective. If you feel the need for more control of critical edges, apply masking fluid to chosen edges. Use your round brushes and Burnt Sienna with a touch of Ultramarine Blue to develop the bark texture on the tree and define the trunk and limbs.

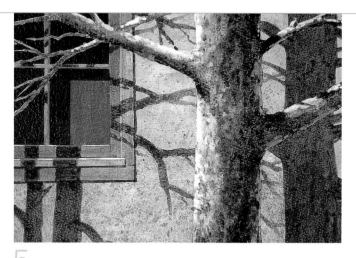

5 Add Finishing Touches

Using your no. 4 round and various mixtures of Ultramarine Blue and Burnt Sienna, refine the details and apply cast shadows. Small highlights such as those on the windowsill may be applied with gesso without compromising the aesthetic of the painting.

Combining Painting Modes

Because acrylics perform equally well in transparent, translucent and opaque modes, all of these can be used in a single painting without violating the integrity of the medium. If the artist's aesthetic choice is transparency, it is comforting to know that all of these modes can be visually unified by the application of transparent washes over the translucent and opaque passages.

Creating Highlights With Opaques

Materials

Surfaces
300-lb. (640gsm)
cold-pressed
watercolor paper

Brushes
No. 2 liner
Nos. 4 and 8 rounds
1-inch (25mm) flat

Acrylics
Burnt Sienna
Ultramarine Blue
Yellow Ochre

Other Supplies
Gesso

Before beginning a painting in a transparent medium such as watercolor or acrylics applied in a transparent mode, you will have to make a decision regarding what to do about highlights. These may be small shapes that add a bit of sparkle and life to the finished painting or they may be significant shapes that contrast darker passages in the painting. Either way, they are likely to be essential components of the composition.

There are basically three methods of incorporating highlights into your painting. You can paint the darker negative shapes, carefully working around the highlights. Or, you can mask the lighter passages with masking fluid (as demonstrated on pages 44-45), allowing you to retain the light passages while freely painting darker ones. The third option, illustrated in the exercise on the next few pages, is to ignore the highlights until the final stages of the painting and then create them with opaque strokes.

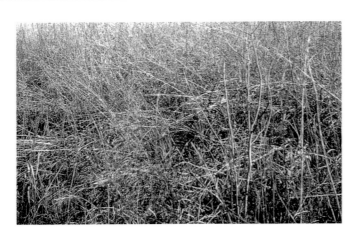

Reference Photograph
The subject selected for this exercise is a field overgrown with tall grass. The multiple layers of delicate details in this subject are sure to provide a significant challenge.

1 Establish Major Mid-Value Shapes
Using your 1-inch (25mm) flat and a mixture of Burnt Sienna and Ultramarine Blue, block out the major mid-value shapes. Don't worry about detail at this point. Use the edge and corner of your brush to get thinner shapes. While the paint is still wet, use a dampened no. 8 round to pull some of the wet paint into pointed shapes at the edges of your application. Look at your subject carefully. Study the shapes and edges. Simplify. You want to capture the essential character of your subject, not duplicate every detail.

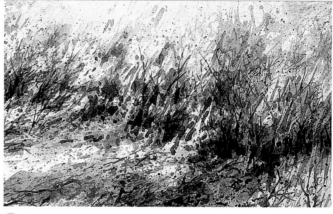

2 Add Major Dark Shapes

Using your no. 8 round, apply the dark shapes using a darker version of the same paint mixture. You are still concentrating on major shapes, not detail. Although you will see the dark and medium value shapes in the finished painting, a final layer of light opaque strokes will break up and soften these shapes visually.

3 Define Details

Using your no. 2 liner, apply medium and dark value details using the same paint mixtures from previous steps. Indicate grass with quick strokes that suggest the direction of growth. Use the splatter technique demonstrated on page 54 to apply a variety of random textures to the grass and the foreground.

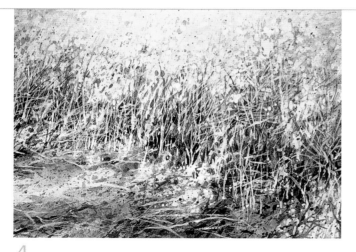

4 Add Finishing Touches

To create the highlights, add just enough water to your gesso to make it flow easily from your no. 2 liner and no. 4 round. Too much water will reduce the opacity of the gesso and prevent it from covering darker shapes. After carefully observing the reference photograph of your subject, apply the final layer of detail and highlights.

After all details are finished, apply a thin wash of Yellow Ochre diluted with a 50/50 mixture of water and matte medium. This will adjust the color and increase the appearance of transparency.

Painting Straight Lines

Materials

Surfaces
300-lb. (640gsm)
cold-pressed
watercolor paper

Brushes
Nos. 1 and 2 liners
Nos. 4 and 8 rounds
1-inch (25mm) flat

Acrylics
Burnt Sienna
Hooker's Green Deep
Ultramarine Blue
Yellow Ochre

Other Supplies
Gesso
Masking fluid (optional)
Straightedge

Whether trying to maintain a clean, straight edge or paint a thin straight line, we would all like to believe that our steady hand and good eye prove sufficient enough. However, there are times when we need more accuracy and consistency than freehand is capable of providing. Luckily for us, there are tools and techniques to accommodate our immediate needs in these instances.

In the exercises on the next few pages you will practice such a technique, first by drawing straight lines of varying width and then by using this technique to complete an actual painting. It requires only one extra piece of equipment, a 2 ½-inch (6cm) wide straightedge. If you don't have a straightedge of this size, I recommend taking the time to pick one up. Having the right equipment will save you a great deal of time and prevent frustration.

Gripping Your Brush
The key to making this technique work is finding the optimal grip on your brush. A good grip resembles that which is commonly used to hold a pencil.

Assuming the Proper Positions
Before you begin, practice assuming the proper positions of your hand, brush and straightedge. Begin by placing your straightedge at a 45° angle to the painting support. Then pull the ferrule of the brush tightly against the straightedge and let the back of your middle finger ride along the top. As the brush moves along the straightedge, use your hand to keep it steady. Laying the straightedge flat on the painting ground and trying to paint a straight line next to the edge will leave you with one of two adverse results. Either the fluid paint mixture will run underneath the edge or the edge will drag through wet paint applications.

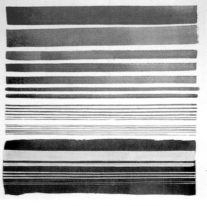

Practice Painting Straight Lines
Prepare fluid mixtures of Burnt Sienna and Ultramarine Blue. Assuming the proper brush/hand/straightedge positions described previously, paint a series of straight lines on the top half of your watercolor paper. Starting with your 1-inch (25mm) flat, use each of your brushes in order of diminishing size. You will find that each brush has distinctive handling characteristics.

Then paint a dark background of Hooker's Green Deep across the bottom half of your paper. After this has dried, repeat the line drawing exercise, painting a light opaque mixture of gesso tinted slightly with Yellow Ochre across the green background.

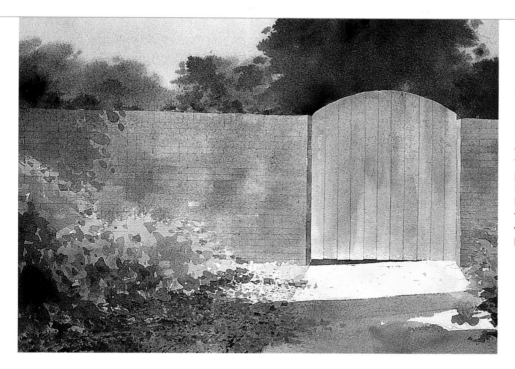

1 Sketch the Scene and Lay In Color

Now that you have practiced painting straight lines, try using them in a painting. On a fresh sheet of paper, rough out a painted sketch that includes a brick garden wall and a wood gate using your no. 8 round and the colors already on your palette. Don't worry about making your composition look exactly like mine—the important thing is that you create a scene in which you can practice drawing straight lines.

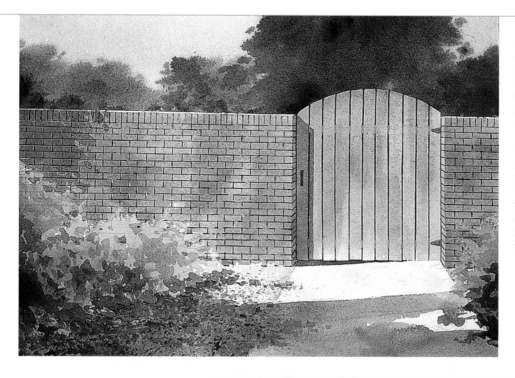

2 Add Lines and Details

Now, use the straight line technique to add the brick joints and the cracks between the boards on the wooden gate. Use your no. 4 round and a mixture of Burnt Sienna and Ultramarine Blue to draw the brick joints. Create the cracks in the wood gate using the same brush and Hooker's Green Deep. It's best if the mix is dark enough to get the desired value in the first stroke so you can avoid having to repeat the stroke numerous times.

Tools of the Trade

If I had to list three tools that have been the most useful to me during my years as an artist, my straightedge would be one of them. It must be the equivalent of the mechanic being able to reach into his toolbox and pull out the right wrench to fit the job at hand. Using my straightedge allows me to concentrate on the painting instead of being distracted by my inability to paint a straight line.

Applying Splatter

The splatter technique is one of the most popular and useful techniques available to watercolor painters. As such, it is also useful to the painter striving to emulate watercolor with his acrylic paints. Before you move on to completing finished paintings, it is important that you try your hand at splattering.

Paint applied with the splatter technique can be spontaneous and random or controlled and calculated. Regardless of the intent with which it is applied, the point of splatter is to suggest texture. This technique is especially useful in landscape painting where a variety of random textures are desired, ranging from rugged stones and rough tree bark to smooth water and soft grass. Splatter also works well for implying texture in man-made objects (see demonstration on page 98). Practice your splatter stroke and then complete the exercise on the following page.

Materials

Surfaces
300-lb. (640gsm)
 cold-pressed
 watercolor paper

Brushes
Nos. 4 round
1-inch (25mm) flat

Paints
Burnt Sienna
Hooker's Green Deep
Ultramarine Blue
Yellow Ochre

Other Supplies
Gesso
Masking fluid (optional)
Scrap paper (optional)

Hand/Brush Position
The success of the splatter technique depends a great deal on your hand position and the way you move your brush. There is only a slight difference in a successful splatter stroke and one that splatters paint all over you and your work space. To avoid disaster, do not hold your brush the way you hold it for conventional applications. Lay the index finger of your painting hand along the top of the brush handle as pictured. Then hold the index finger of your other hand under the brush as illustrated.

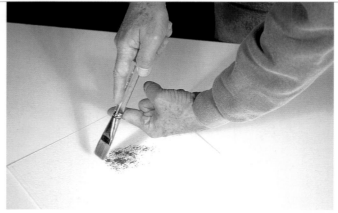

Practice The Stroke
After loading your brush with paint, gently tap it with the index finger positioned under the brush, moving your finger as though it were completing an arc in the air. The paint should be fluid enough to move easily from the brush. You will quickly learn that the more fluid you have on your brush, the larger the splatter texture.

Holding your brush improperly may cause a bouncing action, sending the splatters of paint upward instead of in the direction of the intended stroke. Wear clothing that you don't mind getting dirty when practicing this technique just to be safe.

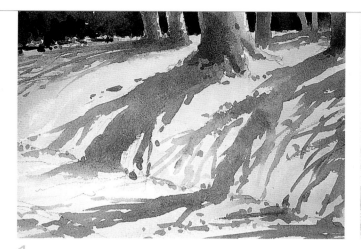

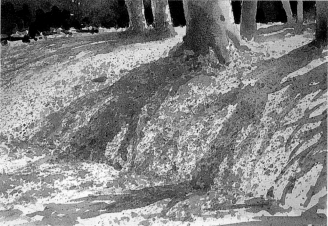

1 Lay in Major Shapes

Dampen your paper with your 1-inch (25mm) flat and clean water. Apply a wash of Yellow Ochre to the ground surface with the same brush. Then using your no. 8 round and a mixture of Burnt Sienna and Ultramarine Blue, define the trees and tree shadows. Create the background trees with the same brush and a mixture of Burnt Sienna and Hooker's Green Deep. Your sketch does not have to look exactly like this one; the objective is to practice the splatter technique.

2 Apply Splatter

Using your 1-inch (25mm) flat, splatter a mixture of Ultramarine Blue and Burnt Sienna to suggest the fallen leaves. Make your strokes deliberate and directional, not arbitrary. (Note: You can use either scrap paper or masking fluid to protect other areas of the painting while applying the splatter.) Add a few fine splatters to indicate the texture of grass and tree bark using the same brush and mixture.

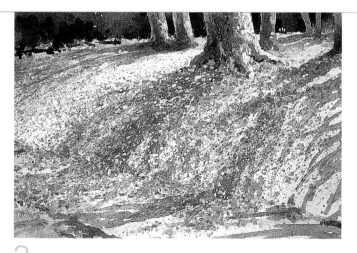

3 Add Finishing Touches

Using your no. 4 round, touch up splatter textures until they look the way you conceived them. This includes altering individual shapes, merging shapes and creating small shadows. Then using your 1-inch (25mm) flat and a mixture of Burnt Sienna and Ultramarine Blue, finish laying in the road. Apply a bit of splatter to the primary tree trunks and roadway to unify the composition using the same brush and mixture. Add a few final splatters of gesso tinted slightly with Yellow Ochre to suggest the highlights.

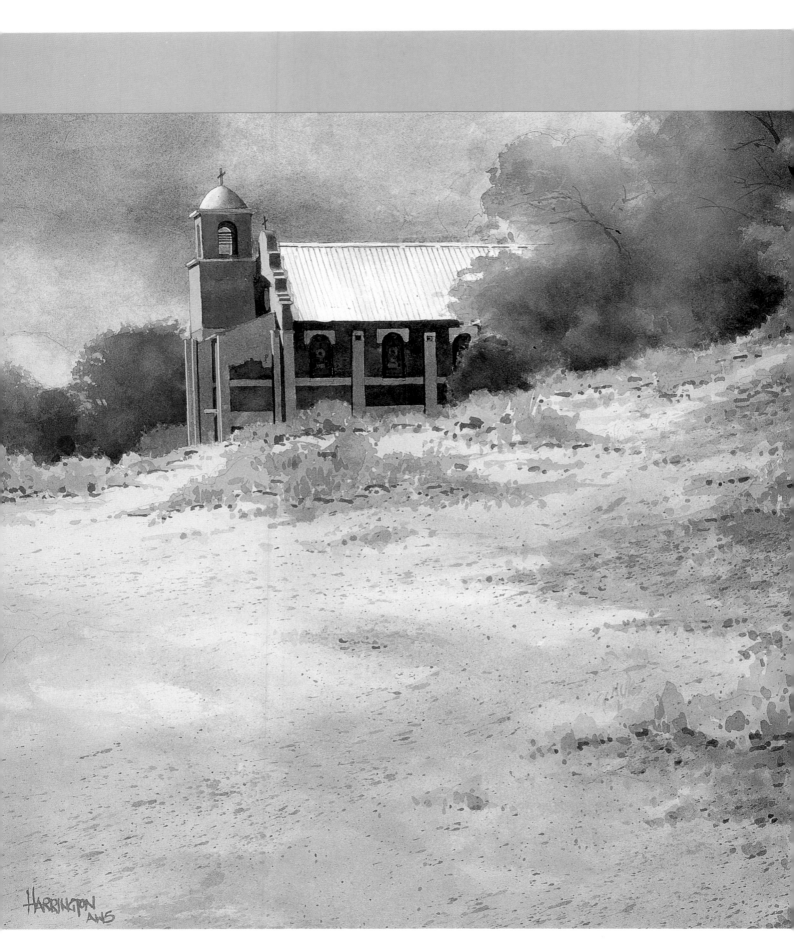

Painting Demonstrations

Like the house builder, you have selected and organized your workspace, collected your tools and considered relevant design issues that will help you create blue prints for your paintings You've also practiced the techniques that will enable you to confidently and efficiently execute your plan. With all of these accomplishments in tow, you're now ready to create your own paintings. This chapter provides you with such an opportunity, taking you step-by-step through ten painting demonstrations. You'll encounter a wide variety of subject matter, ranging from natural landscapes to intricate architecture, selected to present you with an assortment of textures, moods and levels of difficulty. You'll also continue to experience the versatility of acrylics, painting on a number of different supports including watercolor paper, canvas and gesso-primed panels. And, just to remind you that mistakes can be corrected when using acrylics, you'll learn ways in which you can turn an otherwise failed painting into a keeper. Relax, paint and enjoy!

CHURCH AT LAMY
300-lb. (640gsm) cold-pressed watercolor paper / 21" x 29" (53cm x 74cm)

Creating Natural Forms and Textures

Materials

Surface
300-lb. (640gsm) cold-pressed watercolor paper

Brushes
Nos. 4 and 8 rounds
½-inch (13mm) and 1-inch (25mm) flats

Acrylics
Burnt Sienna
Cerulean Blue
Hooker's Green Deep
Raw Umber
Ultramarine Blue
Yellow Ochre

Other Supplies
Gesso
Hair dryer (optional)
Masking fluid
Matte medium
Sketching materials
Spray bottle

My summer trips to the Buffalo National River always leave me feeling inspired. Brimming with natural beauty, this scenic destination boasts clear flowing water, smooth gravel bars and great stone bluffs all set against a beautiful backdrop of green foliage. The combination of all these natural forms and textures makes a great subject for this demonstration, helping you experience the capabilities of acrylics as a transparent water media.

You will find that transparent acrylic washes are especially appropriate for capturing the essence of the water and delicate background foliage. Opaque passages will be used sparingly, only as needed for highlights, leaving the finished painting with the aesthetic of transparent watercolor.

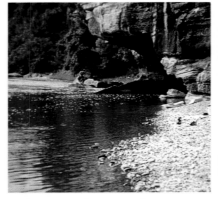

Reference Photograph
This photo is one of hundreds taken during my trips to Buffalo National River. Carefully study the forms, textures and mood inherent in this scene before proceeding with your drawings of the subject.

1 Complete Drawing and Lay Initial Washes
Prepare a full-scale drawing on tracing paper and transfer it to your watercolor paper using graphite transfer paper. Using your 1-inch (25mm) flat, apply a light wash of Hooker's Green Deep to the background foliage and a mixture of Burnt Sienna and Ultramarine Blue to the bluff. Apply a light wash of Yellow Ochre to the gravel bar in the foreground and the sunlit portions of the bluff. Use your spray bottle to keep the surface of the paper wet and the edges soft while painting. Allow your paper to dry, and apply masking fluid to the edges of the bluff, the rock formations between the background foliage and the water, and the edge of the gravel bar.

2 Define the Gravel Bar and Foliage
Paint the first layer of submerged gravel using your 1-inch (25mm) flat and Raw Umber. (This technique is demonstrated in "Using Masking Fluid" on pages 44-45.) With the same brush and Hooker's Green Deep, begin defining the shapes within the background foliage. This application will represent the lightest portions of the foliage in the finished painting. Always allow your paper to dry before applying the next paint application.

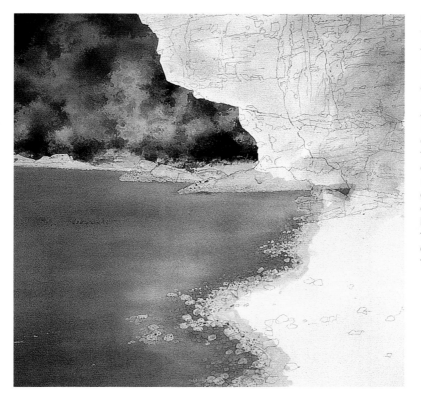

3 Continue Developing Gravel and Foliage, Paint the Water

Apply masking fluid to a second layer of submerged gravel. Still using your 1-inch (25mm) flat, apply another light wash of Raw Umber at the water's edge. Then apply a wash of Hooker's Green Deep to the water. Keep the application soft by using your spray bottle to keep the surface of the paper damp. Using your no. 8 round, add mid-value definition to the background foliage with a darker application of Hooker's Green Deep, being careful to leave light areas in the foliage. After all applications are dry, remove the masking fluid from the edge of the bluff.

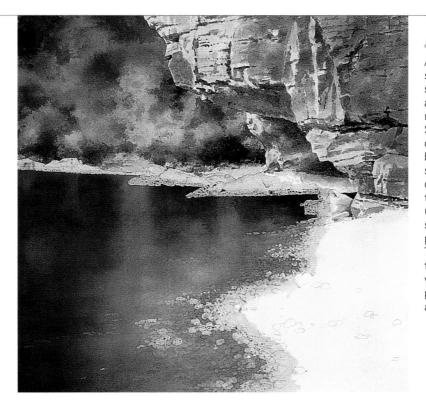

4 Establish the Bluff, Apply Final Wash to Water

Add masking fluid to a third layer of submerged gravel, covering the spaces between the green water and the gravel bar. Using your no. 8 round and a mixture of Burnt Sienna and Ultramarine Blue, begin defining the shapes within the bluff. Add more blue to cool the shaded portions. Then apply a final dark wash of Hooker's Green Deep to the water using your 1-inch (25mm) flat. Dampen the paper surface with your spray bottle to prevent hard edges from forming. To create the lighter reflections in the water, squeeze the water from your no. 8 round and use it to lift pigment from the paper before the application dries.

5 Add More Detail and Paint Reflections on the Water

Remove all masking fluid. Define the stone formations between the water and the background foliage using your no. 4 round and a mixture of Burnt Sienna and Ultramarine Blue. With the same brush and mixture, add definition to the gravel bar, varying value patterns and shaping individual pieces and clusters of gravel. Apply shade and shadows to some of the gravel, including submerged portions. Remember, the gravel is less visible as the water gets deeper, so the detail should diminish. Paint the light reflections on the water using your no. 4 round and gesso tinted with a touch of Cerulean Blue. Create the whitewater in the middle ground by dragging your ½-inch (13mm) flat loaded with gesso across the surface, slightly tilting the brush in the direction of the stroke to create a broken texture. Apply the smaller details in the whitewater and the foreground reflections with your no. 4 round. Glaze the light reflections with a mixture of matte medium, Cerulean Blue and Hooker's Green Deep. Let your paper dry.

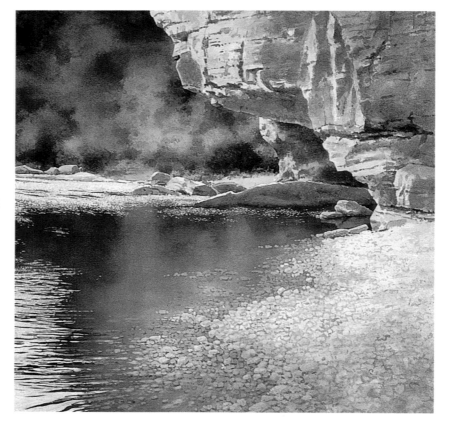

Taking a Closer Look

This detail gives you a closer look at the interface between the gravel bar and the water in the foreground of your painting. If the progressively submerging layers of gravel are not reading properly, adjust them with a slightly opaque mixture of Raw Umber and Hooker's Green Deep. Add more green as the water gets deeper. Adding a bit of gesso to the paint mix will make it translucent.

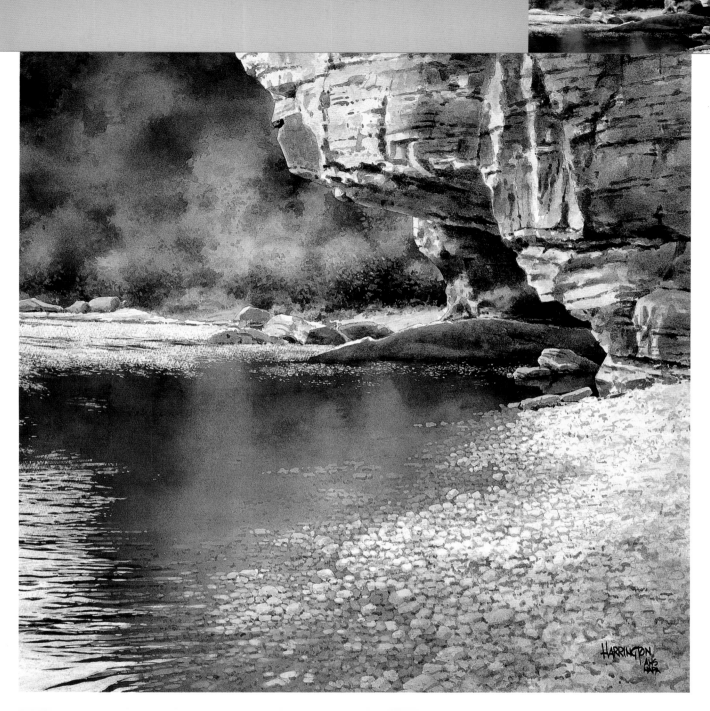

BUFFALO POINT
300-lb. (640gsm) cold-pressed watercolor paper / 21" x 21" (53cm x 53cm)

6 Add Finishing Touches

Add more detail to the bluff area, embellishing the existing darks, using a no. 4 round and a mixture of Burnt Sienna and Ultramarine Blue. With the same brush and paint mixture, add several more dark details to the gravel bar to create interest. Place a few final details in the background foliage using your no. 4 round and an opaque mixture of Hooker's Green Deep and gesso. If any of your values are still a bit light at this point, adjust them by glazing the area with a light mixture of the original colors. Use light glazes of blue to cool the shadows and shaded areas.

Capturing the Brilliance of Light and Color

Materials

Surface
300-lb. (640gsm)
cold-pressed
watercolor paper

Brushes
No. 2 liner
Nos. 4 and 8 rounds
1-inch (25mm) flat

Acrylics
Alizarin Crimson
Burnt Sienna
Cadmium Yellow
Cerulean Blue
Hooker's Green Deep
Raw Umber
Ultramarine Blue
Yellow Ochre

Other Supplies
Gesso
Hair dryer (optional)
Masking fluid
Sketching materials
Spray bottle

For this demonstration we will go to the American southwest for inspiration. The aesthetics and mystique of this land have inspired generations of artists, and the harsh but visually powerful landscapes make intriguing subjects for paintings. Although the massive forms of the mesas are visually heavy and solid, the beautiful late afternoon light makes their earthy colors glow like giant lanterns. Transparent acrylics are ideal for capturing this spectacular show of light and color.

Reference Photograph
This photograph was taken in northern New Mexico. It only takes one trip through this awesome landscape to understand why it continues to attract so many artists. Study the photograph carefully, observing the colors, textures and value patterns created by the cast shadows.

Planning Your Composition
To simplify and strengthen the compositions used for your paintings, always crop unwanted portions of reference photographs before you begin painting. For this demonstration, I cropped out the sky to the far left as well as a good deal of the foreground in order to focus more closely on the mesa. After cropping the reference photograph, I prepared a value sketch of the subject. Using a no. 4 round and a mixture of Burnt Sienna and Ultramarine Blue, I blocked out the major dark, medium and light shapes. Remember: When making value sketches, don't concern yourself with small details. These sketches are merely guides to help you make design decisions.

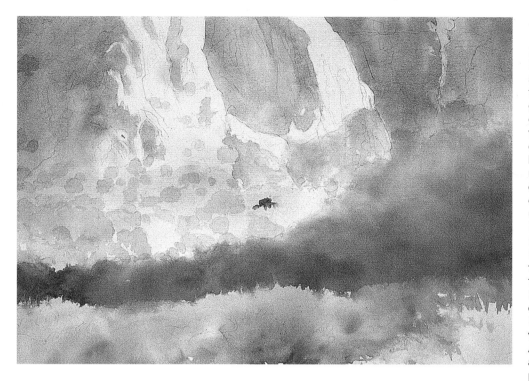

1 Define Major Shapes and Lay First Washes

Using a soft graphite pencil, lightly draw the three major shapes of your composition—the background mesa, middle ground trees and foreground grasses—on a full sheet of watercolor paper. Keep your drawing simple, as details will be added later. Once the major shapes have been defined, apply light washes of color to each of the shapes using your 1-inch (25mm) flat. Use a varying combination of Burnt Sienna, Ultra-marine Blue and Alizarin Crimson for the mesa, Cerulean Blue for the foreground grasses, and Hooker's Green Deep for the dark middle ground trees. Keep all edges soft, using your spray bottle as needed. Allow your paper to dry, using a hair dryer to speed the process if necessary.

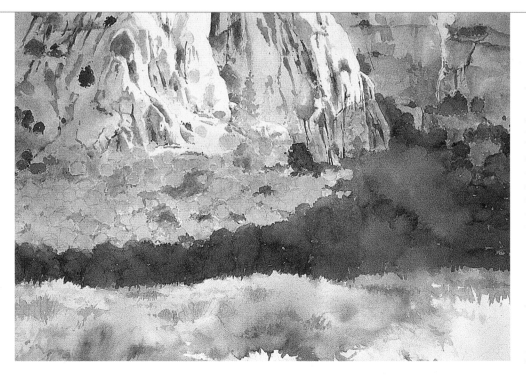

2 Begin Middle Values

Begin adding detail to each of the major shapes by applying middle values. Remember: Although inappropriate applications can be altered later with translucent or opaque overlays, acrylics can't be lifted from your paper after they are dry. Thus, use your graphite pencil to place some of the smaller shapes and details within each of the major shapes to ensure your paint applications are properly located. Then, with your no. 4 round and the same colors used in step 1, place darker values within the major shapes to indicate detail and shadow, paying particular attention to the mesa and the foreground. Again, allow all applications to dry before moving on to the next step.

3 Adjust Color and Overall Values

Further define the primary shapes by adjusting their dominant colors and values. Begin with the foreground, applying a light wash of Raw Umber over the initial application of Cerulean Blue using your 1-inch (25mm) flat. This will subdue its intensity and allow the earthy colors of the mesa to be more dominant. Next move to the middle ground, applying another wash of Hooker's Green Deep over the shaded areas. Then, wash the lower portion of the mesa with Burnt Sienna, and adjust the shaded side of the mesa with a cool mixture of Burnt Sienna, Ultramarine Blue and Alizarin Crimson. Continue to avoid hard edges, using your spray bottle to keep the surface of the paper damp. Refer to your reference photograph and value sketch to determine when the overall color and value relationships are correct.

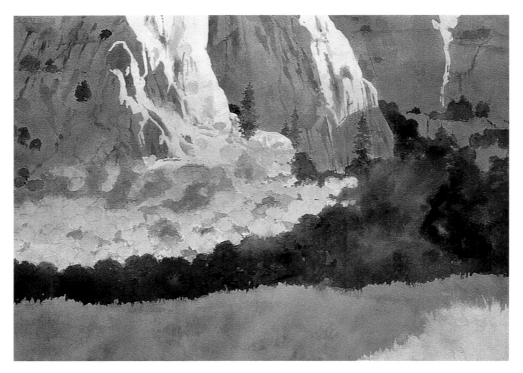

4 Detail Foreground Grasses

Using your no. 8 round and a dark mixture of Cerulean Blue and Raw Umber, apply shade and shadow details to the foreground plants. Don't over-do the detail; a few quick vertical strokes indicating the direction of the plant growth will suffice. Minimal detail here encourages the eye of the viewer to focus on the primary focal point—the distant mesas. If some of your strokes get too large or too dark, they can be broken up later with an opaque mix.

5 Embellish Middle Ground Trees

Because the middle ground is in shadow, it will require less detail than other parts of the painting. Use your no. 8 round and Hooker's Green Deep with very little water added to shape and define tree clusters. Remember to vary the size and shape of the trees to avoid monotony within the composition. If necessary, occasionally mist the paint application with your spray bottle to keep the edges soft. Allow your paper to dry.

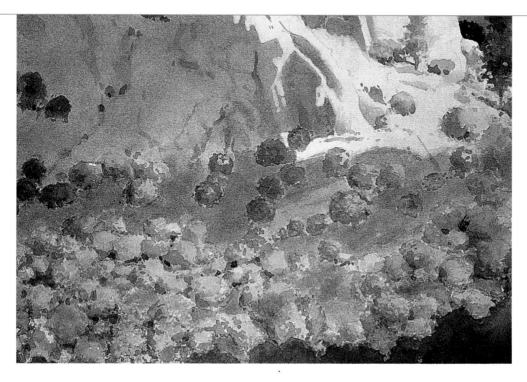

6 Paint Mesa Details

Notice that the trees at the base of the mesa are closer to the focal point and are mostly in the sunlight. Consequently, they should draw more attention. Use your no. 4 round and Hooker's Green Deep warmed slightly with a touch of Burnt Sienna to shape these trees. Shades and shadows should be defined by the primary light source (the sun), which is coming from the upper right-hand side of the composition. Indicate the shaded side of the trees with a darker application of Hooker's Green Deep. Then, still using your no. 4 round, add a pale wash of Cadmium Yellow to the sunlit side of a few trees, creating variety in the color. Let this dry.

7 Paint Light and Shade at Base of Mesa

The primary focal point of your composition is near the base of the mesa in the top left quadrant. This area should contain the most refined detail. Add smaller sunlit patches on the ground among the trees at the base of the mesa using your no. 4 round and an opaque mixture of Burnt Sienna, Ultramarine Blue and gesso. With the same colors, mix a darker version by adding less gesso. Use this mix to paint the shadows cast by the trees. Next, with a mixture of Burnt Sienna, Ultramarine Blue and Alizarin Crimson, define the smaller shadow shapes in the mesa. The darkest values will be the shadows in the crevices. Cool all of the shade and shadow colors by increasing the amount of Ultramarine Blue in the mixture. Let this dry.

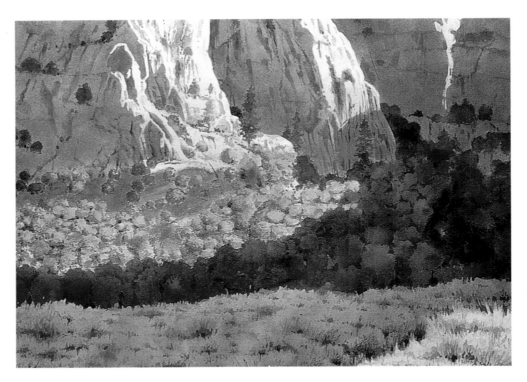

Putting It in Perspective

Observe the diminishing scale of objects as they become more distant. This is a good time to add a few darker details to the mesa where needed. You can use your no. 4 round and a mixture of Burnt Sienna, Ultramarine Blue and Alizarin Crimson to define some of the smaller shapes.

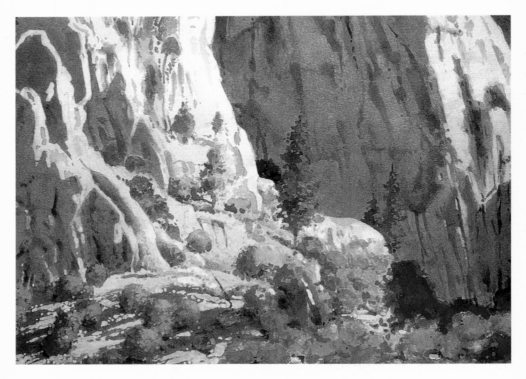

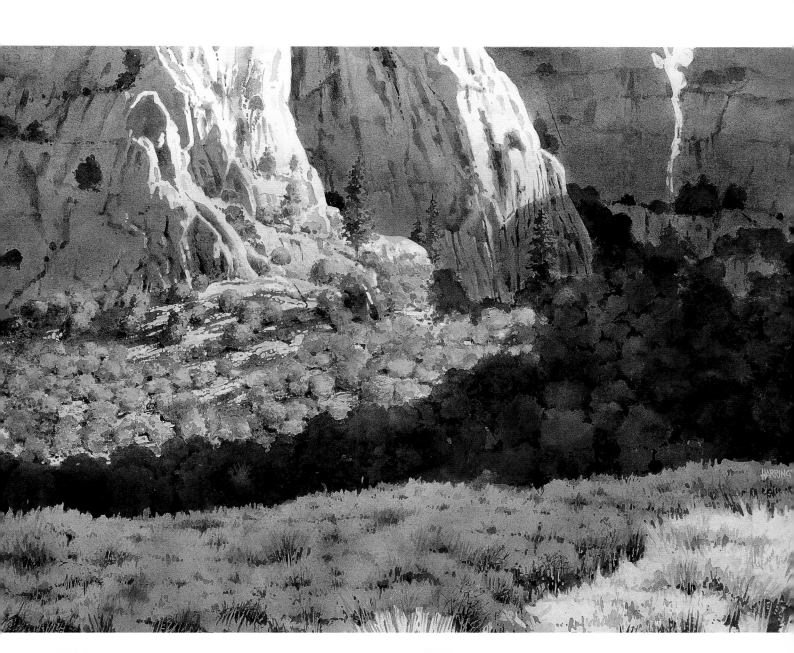

NEAR GHOST RANCH
300-lb. (640gsm) cold-pressed watercolor paper / 21" x 29" (53cm x 74cm)

8 Add Final Touches

With the same brush and opaque paint mixture used in step 7, add small, light highlights to the mesa (refer back to the reference photograph on page 62 for the precise location of these highlights). Break up a few of the larger dark strokes in the foreground plants with your no. 2 liner and an opaque mixture of Cerulean Blue, Raw Umber and gesso. Use thin, vertical strokes that emulate the vertical growth of the plants. Then with your no. 4 round and a mixture of Hooker's Green Deep lightened slightly with gesso, add a few lighter shapes to the dark middle ground trees, shaping individual trees and breaking up any large awkward masses. Be sure to dampen the paper with your spray bottle before applying this mixture. This will keep edges soft and allow the paint to blend nicely with previous applications. Repeat this process until you are satisfied with the results, allowing each paint application to dry before proceeding to the next.

Painting Translucent and Reflective Objects

Materials

Surface
300-lb. (640gsm)
cold-pressed
watercolor paper

Brushes
No. 4 round
1-inch (25mm) flat

Acrylics
Burnt Sienna
Hooker's Green
Hooker's Green Deep
Ultramarine Blue
Yellow Ochre

Other Supplies
Gesso
Hair dryer (optional)
Masking fluid
Sketching materials
Spray bottle
Straightedge

Acrylics used in a transparent mode are also excellent for rendering translucent and reflective objects. They have a distinct advantage over watercolor paints, as they can accommodate consecutive multiple glazes without disturbing earlier applications. Such a benefit eliminates the need to get the color and value of reflective surfaces right the first time. The glass like qualities of the figurines chosen for this demonstration make them the perfect subject to illustrate acrylics' ability to depict translucent objects.

Reference Photograph
These onyx carvings decorate the mantle over my fireplace. Every time I see them I am intrigued by their translucency and subtle color variations. They seem to virtually glow under the light, and the shadows on the wall behind them echo their form, creating the illusion of a ghost herd. All of these fascinating elements present good compositional possibilities and make these figurines a challenging subject for your painting.

1 Complete Drawing and Lay Initial Wash
Prepare a full-scale line drawing on tracing paper. Once finished, transfer the drawing to your watercolor paper using graphite transfer paper. Before laying the first wash of color, cover the white elephant on the far right with masking fluid. Then, apply a wash of Yellow Ochre to the entire sheet using your 1-inch (25mm) flat. Use your spray bottle to keep the surface of the paper wet while applying the wash.

Throughout this demonstration, allow your paper to dry after each paint application, moving on to the next step only once your paper has dried thoroughly. I recommend using a hair dryer to speed up this process.

2 Paint the Wall

Apply masking fluid to the other elephants. Then, using your 1-inch (25mm) flat and a mixture of Burnt Sienna and Ultramarine Blue, paint the wall behind the elephants.

3 Splatter Texture on the Wall

Splatter the wall to indicate light texture using your 1-inch (25mm) flat and slightly darker variations of the mixture used in step 2. Avoid getting the splatter on other portions of the painting, protecting these areas with pieces of paper before applying the splatter.

4 Paint the Artwork Above the Mantle

Paint a facsimile of the painting hanging above the mantle. Use your 1-inch (25mm) flat and a mixture of Burnt Sienna and Ultramarine Blue to create the building within the picture as well as the picture frame. Use Hooker's Green Deep for the background tree within the painting and Ultramarine Blue mixed with gesso for the patches of sky seen through the tree foliage.

5 Add Shadows

While the elephants are still masked, paint their shadows using your no. 4 round, Burnt Sienna and Ultramarine Blue. Remember that the light reflects off the onyx elephants into the shadows, thus varying the colors of the shadows. Illustrate this by allowing the colors to mix on your paper instead of mixing them on your palette. Allow your paper to dry.

6 Paint the Mantle

Remove all masking fluid from your painting. Add the base color for the wood mantle using your 1-inch (25mm) flat and a mixture of Yellow Ochre and Burnt Sienna. Use the "Painting Straight Lines" technique on page 52 to maintain straight edges and lines. Create the dark strip below the mantle and the deep groove in the mantle near the top with the same brush and a mixture of Ultramarine Blue and Burnt Sienna. Then, with your straightedge, add horizontal lines to indicate the dimension and shaded areas of the mantle using your no. 4 round and a mixture of Ultramarine Blue and Burnt Sienna. Before this application can dry, use your straightedge and a brush dampened with clean water to soften the edges of these lines. Let this dry.

7 Detail the Mantle

Use your no. 4 round and Burnt Sienna to paint the wood grain on the mantle. Study the reference photograph to establish the physical characteristics of the grain. Keep the contrast with the basic wood color subtle.

8 Paint the Elephants

Paint the colored elephants using your no. 4 round and various mixtures of Burnt Sienna, Ultramarine Blue and Hooker's Green. Apply multiple washes until the colors and values are satisfactory, paying particular attention to the veins of color running through the onyx. For the darkest values and colors, use more Burnt Sienna in your mixture. Water down the mixture to create the lightest values and colors. Don't worry about saving the lightest highlights, as these will be added later with gesso. Next, paint the white elephant in a similar fashion using your no. 4 round and a warm gray mixture of Burnt Sienna and Ultramarine Blue. Add the slight hints of green with a very pale application of Hooker's Green after previous applications are dry.

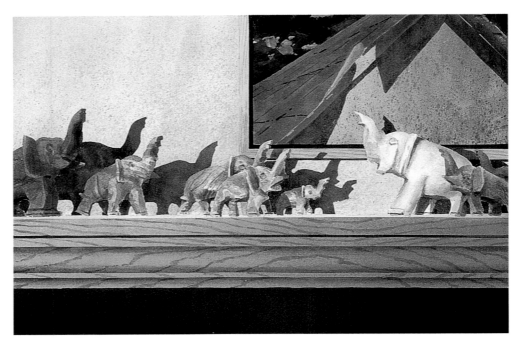

9 Detail the Elephants

Using your no. 4 round and a thin mixture of white gesso, create the lightest highlights on the elephants. The more water you add to the gesso mixture the less it will cover previous applications of color. Multiple applications are often required to reach desired opacity.

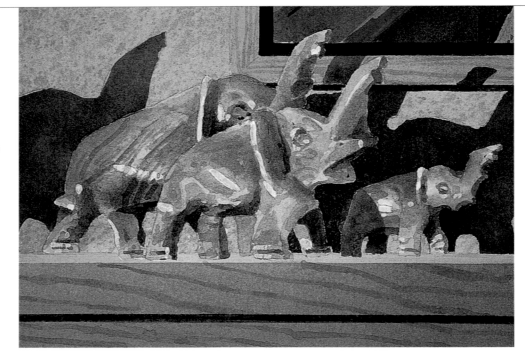

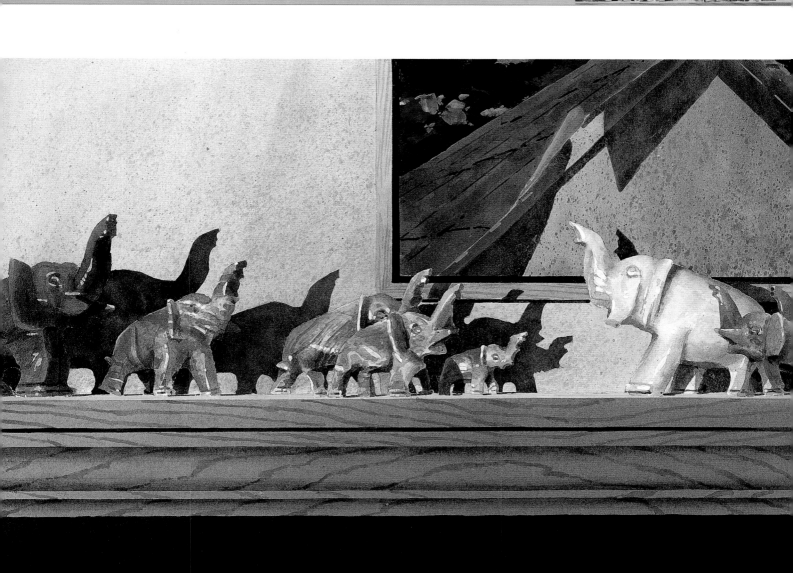

DANCING WITH A WHITE ELEPHANT
300-lb. (640gsm) cold-pressed watercolor paper / 14" x 21" (36cm x 53cm)

10 Add Final Touches

Make any needed value adjustments by applying selective washes to problem areas. Add remaining details such as the small horizontal shadows at the elephants' feet using your no. 4 round and a mixture of Burnt Sienna and Ultramarine Blue. Also make sure that the horizontal surface under the elephants' feet is light enough to contrast the face of the mantle. If necessary, lighten this area using your no. 4 round and gesso tinted slightly with Yellow Ochre.

Portraying Intricately Detailed Subjects

Materials

Surface
300-lb. (640gsm) cold-pressed watercolor paper

Brushes
No. 4 round
1-inch (25mm) flat

Acrylics
Alizarin Crimson
Burnt Sienna
Ultramarine Blue
Yellow Ochre

Other Supplies
Gesso
Hair dryer (optional)
Masking fluid
Sketching materials
Spray bottle
Straightedge

Architecture has always been popular subject matter for paintings. Its design and construction have been vehicles through which man has given expression to his finest creative energies. None of these creations have been more loved and respected than Europe's great cathedrals.

Although this composition introduces a drawing challenge, it presents an ideal opportunity for you to experience one of acrylic's primary benefits—the ability to combine transparent, translucent and opaque passages into a single painting. The latitude to add translucent and opaque applications to existing transparent washes frees you from the tedious process of saving the white of your paper where highlights are required, making acrylic the perfect medium to paint intricate subjects such as architecture.

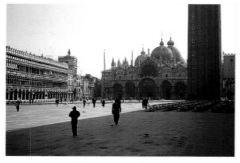

Reference Photograph
This photograph of St. Mark's Cathedral in Venice, Italy, was taken early in the morning before the plaza had attracted its usual crowd of people and pigeons. The morning sun, coming from behind, backlit the cathedral and cast long, cool shadows on the plaza. The mood is terrific for a painting. Feel free to crop out some of the photograph in order to create a stronger focus on the cathedral.

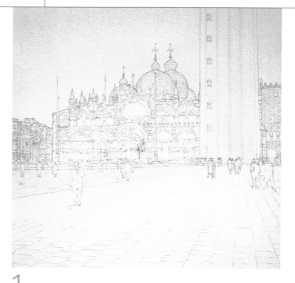

1 **Complete Drawing and Lay Initial Wash**
Complete a full-scale drawing on tracing paper, then transfer the drawing to your support using graphite transfer paper. Further refine your drawing directly on the watercolor paper using a graphite pencil. After your drawing is complete, use your 1-inch (25mm) flat and spray bottle to wet the entire sheet of paper with clean water. While still wet, apply a thin wash of Yellow Ochre to your paper, making the wash a bit heavier near the horizon line. Your spray bottle will help keep the paper damp until the wash application is complete. As with the previous demonstrations, allow your paper to dry between all applications. Use a hair dryer to speed up the process.

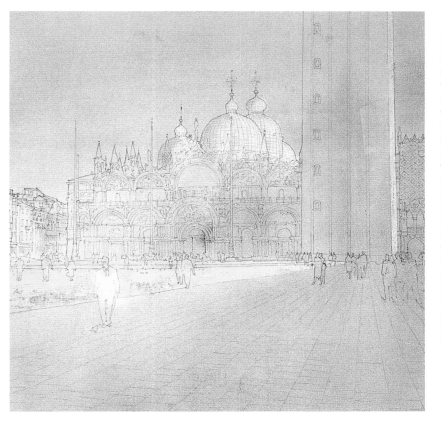

2 Apply the Underpainting

Before adding more color, apply masking fluid to the sunlit areas of the plaza and the buildings on the extreme left of the composition. This will preserve the white of the paper during subsequent paint applications. Next, wet the paper with clean water using your spray bottle and 1-inch (25mm) flat. With the same brush, apply a wash of Ultramarine Blue muted slightly with Burnt Sienna to the entire sheet of paper. This wash serves as an underpainting for the building and the plaza as well as the final application over the sky area. Because it is transparent, the previously applied Yellow Ochre will show through, creating a warm glow in the sky.

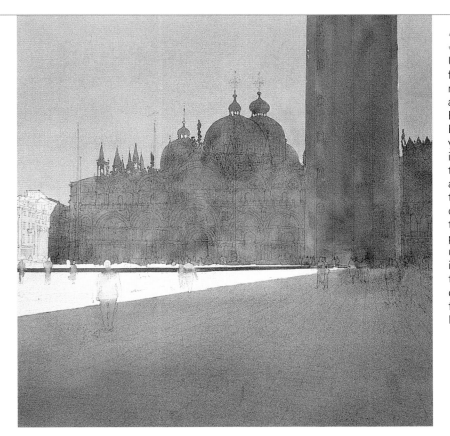

3 Paint Cathedral and Foreground Shadow

Using your 1-inch (25mm) flat for large areas and your no. 4 round for the smaller details, apply a mid-value mixture of Burnt Sienna and Ultramarine Blue to the entire cathedral. If you feel insecure about painting the intricate edges at the top of the cathedral, you can apply masking fluid around the edges before laying in the color. Paint the shaded area in the right foreground of the plaza with the same colors used for the cathedral, allowing the blue color to dominate this large shadow. This application serves as a basecoat for the pavement of the plaza. Let your paper dry.

4 Establish Cathedral Details

Prepare various darker versions of the color mixture used in step 3. Use your no. 4 round to apply shadow details to the cathedral, establishing the arched doorways and the ornate design of the structure. Paint vertical lines around the doorways at the base of the cathedral to define the shapes of the stone. Pay particular attention to the areas just above each doorway and window where murals appear, using the reference photograph to determine the correct colors and values. Apply the darkest values to the entryways and windows of the cathedral to create the illusion of depth. This is the most time-consuming part of the painting. Refer to the reference photograph often, and be patient and consistent—the end product is well worth it.

5 Paint the Campanile and Add Further Details

Using the your no. 4 round and a mixture of Burnt Sienna and Ultramarine Blue, add the shaded side of the uppermost domes. Mask the edges outside the campanile and the small windows on the face of the campanile with masking fluid. These edges are highly visible, so it's important that they be straight. If you have already drawn the figures at the base of the campanile, mask these as well. Using your 1-inch (25mm) flat, apply a wash of Burnt Sienna to the face of the campanile. Then with your no. 4 round, apply touches of the same color to the base of the uppermost dome of the cathedral. This repetition of Burnt Sienna helps to tie the two structures together. Still using your no. 4 round, paint the pediment above the main entry with Ultramarine Blue, leaving a white space in the center for the small figurehead in front of the pediment.

6 Create Highlights and Soften Edges

Use diluted gesso to create the light highlights on the domes and spires at the top of the building. This allows the color from previous applications to show through when the wash is dry. Apply a stroke of this mixture to the lightest edge of the domes using your no. 4 round. Clean your brush thoroughly and dampen edges you want to soften. Manipulate the paint with your brush, giving the dome the appearance of roundness. Keep the paint mix light by adding water, and apply multiple washes. Add several more highlights on the spires and roof, this time with small strokes of undiluted gesso. These strokes will dry white, obscuring previous applications. Finally, use your no. 4 round and Yellow Ochre to paint the small figure in front of the blue pediment.

7 Remove Masking and Paint Straight Lines

Remove all masking fluid from your painting. Add more gesso to the gray mix already on your palette and paint a few highlights to the shaded face of the building. These highlights should be only slightly lighter than the lightest value previously used. Review the "Painting Straight Lines" instructions on page 52, then paint the red flagpoles using your no. 4 round and Alizarin Crimson mixed with a touch of opaque gray. Add a small, white highlight to the sunlit side of the pole. Then with your straightedge, no. 4 round and a mixture of Burnt Sienna and Ultramarine Blue, create the thin shadows on the face of the campanile. Paint the sunlit right edge of the campanile with a mixture of Burnt Sienna and gesso, and the grid pattern on the face of the building at far right with a transparent application of Burnt Sienna.

8 Refine the Pavement in the Foreground Shadow

Suggest the texture of the pavement in the large foreground shadow to the right, applying various mixtures of Burnt Sienna and Ultramarine Blue with your no. 4 round. Varying the color and value of the pavement adds a sense of realism, as it suggests that the pavement is aged and somewhat weathered. It also helps to break up monotony. Use a straightedge to create the individual blocks in the pavement, adding joints with your no. 4 round and a dark mixture of Burnt Sienna and Ultramarine Blue. Take care not to overdo the grid of lines. You don't want them to dominate the composition.

9 Finish the Plaza

The sunlit buildings at the left of the cathedral provide a visual boundary for the plaza. Finish them with a light wash of Yellow Ochre. Add a few details, including small patches of Burnt Sienna to indicate the tile roof and shadows. Keep these buildings in the distance by not overdoing the detail and contrast. Subdue the brightness of the left side of the plaza with a glaze of light cool gray. This will focus more attention on the sunlit area near your intended focal point. If you feel that the large foreground shadow needs value or color adjustments at this point, you can make them by applying thin glazes of Burnt Sienna or Ultramarine Blue, depending on the need.

ST. MARK'S CATHEDRAL
300-lb. (640gsm) cold-pressed watercolor paper / 21" x 21" (53cm x 53cm)

10 Add Final Touches

Finish your painting by adding the people and pigeons to the plaza. Use your no. 4 round and a dark gray mixture of Burnt Sienna and Ultramarine Blue to paint the shapes of the people and the pigeons. Avoid the temptation to add too much detail. You don't want people and pigeons upstaging your primary subject, the cathedral. Add a bit of gesso to your gray mixture to paint white shirts and highlights. Mix the flesh colors with Yellow Ochre, Alizarin Crimson, Ultramarine Blue and gesso. Add a few colored garments with muted opaque mixtures of gray-blue and gray-crimson for interest.

Depicting the Reflective Nature of Water

Materials

Surface
300-lb. (640gsm) cold-pressed watercolor paper

Brushes
No. 2 liner
No. 4 round
1-inch (25mm) flat

Acrylics
Alizarin Crimson
Burnt Sienna
Ultramarine Blue
Yellow Ochre

Other Supplies
Gesso
Hair dryer (optional)
Masking fluid
Sketching materials
Scrap paper
Spray bottle

As an artist, I am constantly amazed with the variety of terrain and subject matter available to the landscape painter. I chose a common sight in the southern United States for the subject of this landscape. As a kid we called them swamps—shallow bodies of water that went from almost dry in the summer to flooded during the rainy seasons. When the water is still, swamps act like mirrors, reflecting images of adjacent objects. I just couldn't resist trying my hand at painting such captivating reflections. The water, coupled with the texture of the grasses and set against a background of winter trees, makes an intriguing subject for a painting.

In completing this demonstration you will once again take advantage of acrylics' ability to comfortably accommodate a combination of transparent, translucent and opaque applications in the same painting. Enjoy!

Reference Sketch
The painting in this demonstration was not based upon a single existing subject; rather, it is a composite of multiple images from my memory. I combined these images into one compositional study, focusing on major values and shapes rather than details. This sketch serves as a basic reference for your full-scale drawing.

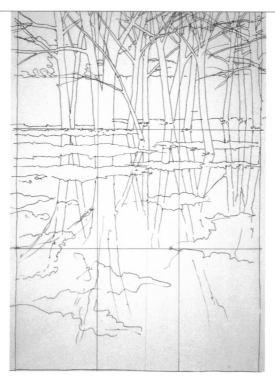

1 Complete Drawing
In the absence of a detailed photo reference, a full-scale drawing will allow you to define enough detail to get started on your painting. To prevent having to make corrections on your watercolor paper, work out your drawing on tracing paper. Once you are satisfied with your drawing, transfer it to your support using graphite transfer paper.

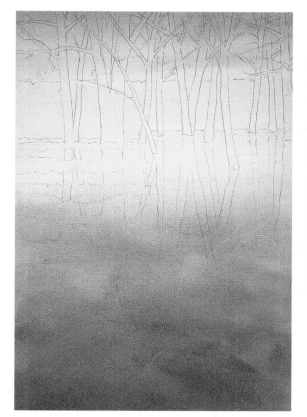

2 Lay Initial Washes

Using your 1-inch (25mm) flat, wet your paper with clean water and lay a thin wash of Yellow Ochre. While still wet, add touches of Ultramarine Blue to the sky and foreground areas. If the washes appear too light once they are dry, repeat this process until you achieve the desired color and value. When laying successive washes, be sure to use your spray bottle to keep your paper wet and prevent hard edges from forming. Allow each application to dry before applying the next, using a hair dryer to accelerate the process if you choose.

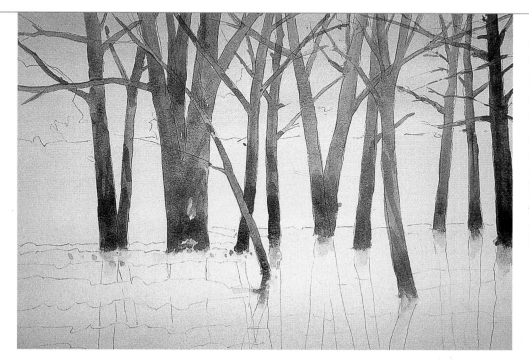

3 Rough in Middle Ground Trees

Using your no. 4 round and a mixture of Burnt Sienna and Ultramarine Blue, rough in the middle ground trees. This application will represent the lightest values in the trees—darker values and details will be added later. After the tree shapes have been loosely defined, cover them with masking fluid to protect them from the paint applications in steps 4 and 5. Allow your paper to dry.

4 **Paint Background Trees**
Wet your paper from the base of the background trees up to the sky using your 1-inch (25mm) flat and clean water. With the same brush, apply a rich mixture of Burnt Sienna to the tree shapes in the background. To create the darker areas in these trees, drop in touches of pure Ultramarine Blue while the paper is still wet, allowing the colors to mix on your paper. Paint the distant trees behind the largest middle ground tree in the same manner, using more Ultramarine Blue. Suggest a few tree trunks in the background foliage using your no. 2 liner and a mixture of Burnt Sienna and Ultramarine Blue.

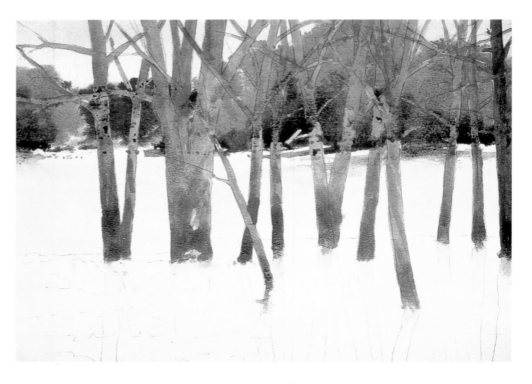

5 **Detail the Meadow**
Dampen the meadow area behind the middle ground trees using your 1-inch (25mm) flat and clean water. Then, add detail to this area, applying a wash of Yellow Ochre followed by a few horizontal strokes of Burnt Sienna and Ultramarine Blue. To maintain variation and create interest in the meadow, avoid overmixing the colors and overworking your brush-strokes. Once this dries, cover the lower portion of your painting with a piece of scrap paper. Then with your 1-inch (25mm) flat and some Burnt Sienna, splatter the forward edge of the meadow to suggest fallen leaves and grass.

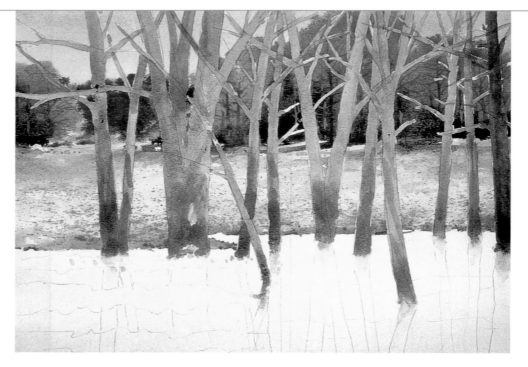

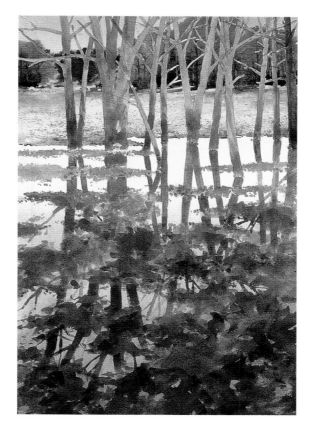

6 Add Swamp Grass and Tree Reflections

Once your paper has dried, remove all masking fluid from the middle ground trees. Then using your no. 4 round and a mixture of Burnt Sienna and Ultramarine Blue, define the shapes of the grass and reflections in the swamp, being careful to preserve the lighter shapes that represent water.

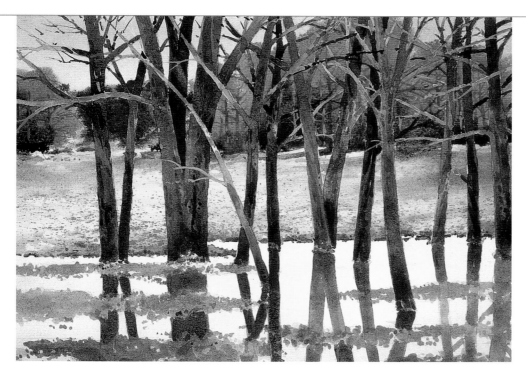

7 Finish Middle Ground Trees

Now that the background trees and meadow are finished, the initial paint applications on the middle ground trees appear too light. Darken portions of these tree trunks using your no. 4 round and a mixture of Burnt Sienna and Ultramarine Blue. As you do this, be aware of the need for variation in color and value. Create lighter highlights by adding a bit of gesso to your mixture. This opaque mixture is especially useful where lighter shapes, such as limbs, cross in front of darker objects, such as other limbs, tree trunks or the background trees.

8 Place Darker Values in Grass and Water

Darken the reflections and shadows in the water and foreground grass using your no. 4 round and a mixture of Burnt Sienna and Ultramarine Blue. Once this dries, wet the foreground with your spray bottle and apply a very thin wash of Alizarin Crimson using your 1-inch (25mm) flat. This breaks the monotony of the painting, adding a hint of color variety.

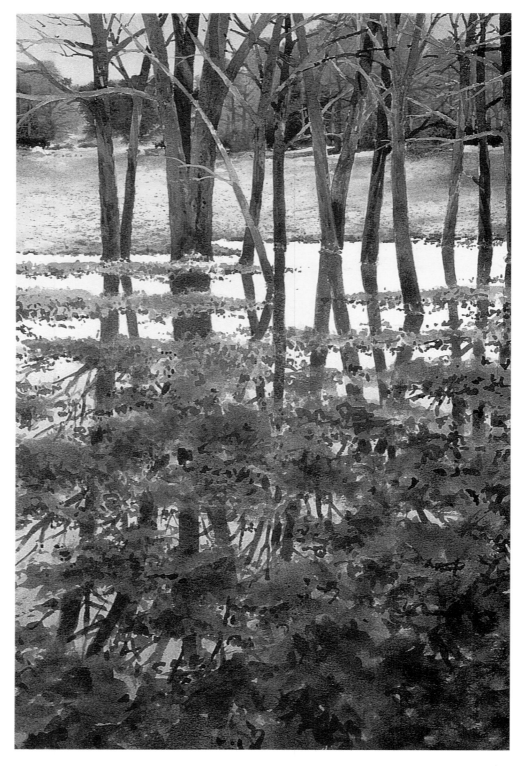

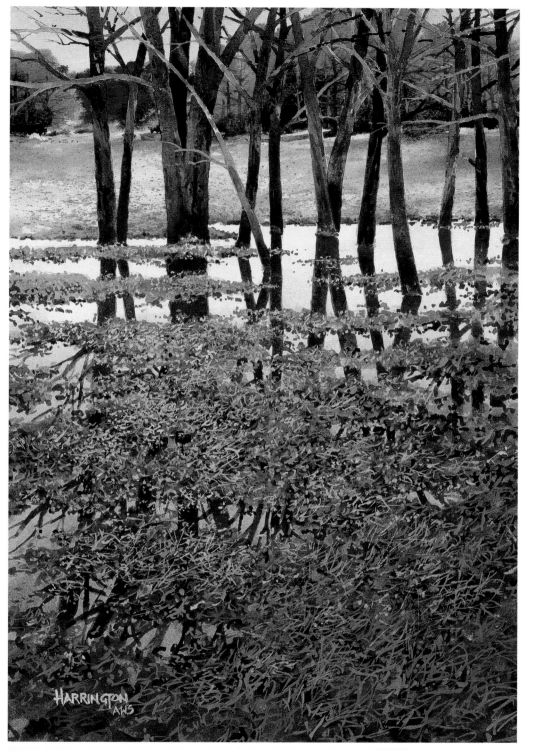

9 Add Final Touches

Apply dark highlights to the grass in the foreground with an opaque mixture of Burnt Sienna, Ultramarine Blue and gesso. Add only enough water to make the mixture fluid, and place the highlights using your no. 2 liner. Remember, you are painting winter grass, so some blades stand upright while others lay nearly flat. Thus, maintain a wide variety in the size, shape and direction of your strokes to accurately depict the condition of the grass. Add the lightest highlights to the grass using your no. 2 liner and gesso tinted slightly with Yellow Ochre.

REFLECTIONS IN A LOUISIANA SWAMP
300-lb. (640gsm) cold-pressed watercolor paper / 21" x 14" (53cm x 36cm)

Using Opaques in Tight Spaces

Materials

Surface
300-lb. (640gsm)
 cold-pressed
 watercolor paper

Brushes
No. 2 liner
No. 4 round
1/2-inch (13mm) and
 1-inch (25mm) flats

Acrylics
Alizarin Crimson
Burnt Sienna
Cerulean Blue
Hooker's Green Deep
Ultramarine Blue
Yellow Ochre

Other Supplies
Gesso
Hair dryer (optional)
Masking fluid
Matte medium
Sketching materials
Spray bottle
Straightedge

Proponents of acrylics justifiably argue that acrylics are the most versatile painting medium available. As you already know, one of the many characteristics that support this argument is the freedom to combine transparent, translucent and opaque modes in the same painting without violating the integrity of the medium. This demonstration further illustrates such flexibility, beginning with transparent washes and ending with opaque overlays.

Applying opaques over already dried transparent washes lends itself to numerous painting styles, including the more controlled style that we will use to paint the house in the reference photograph. Using opaques for areas where extremely tight spaces or straight lines occur is much simpler than attempting to save white spaces on your paper. Opaque overlays also make it easy for you to adjust mistakes, as they can be painted over with ease.

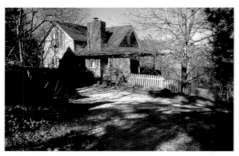

Reference Photograph
Perched on a picturesque hillside, this weathered house still shows signs of its more prosperous days.

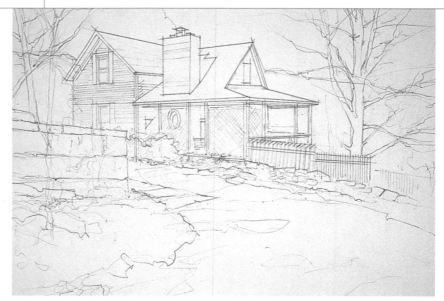

1 **Complete Drawing**
Construct a full-scale drawing of the subject on tracing paper. Be as accurate with the details as you can. Architectural subjects are not as tolerant of inaccuracies in the drawing process as pure landscapes. After you have finished the drawing, transfer it to your watercolor paper using graphite transfer paper. Since all pencil lines will eventually be covered with opaque paint applications, you can use your graphite pencil freely on the watercolor paper to refine your drawing.

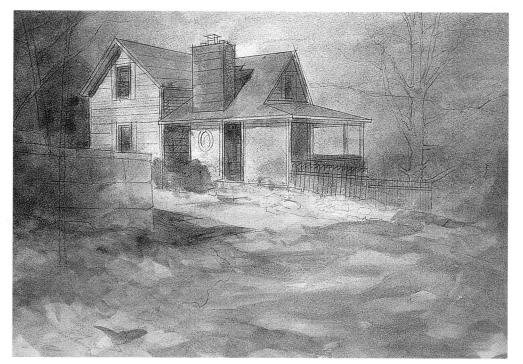

2 Lay Transparent Washes

Keeping in mind that these initial washes will eventually be covered by opaque applications, you may use this step to confirm drawing and composition decisions, especially value and temperature relationships. Using your 1-inch (25mm) flat, first apply a transparent wash of Ultramarine Blue to your paper. Follow this with several washes of Burnt Sienna and Ultramarine Blue, applying the darkest values to the far left side of the composition. Switch to your no. 4 round to paint in the smaller shapes. As always, let your paper dry between all paint applications in this demonstration.

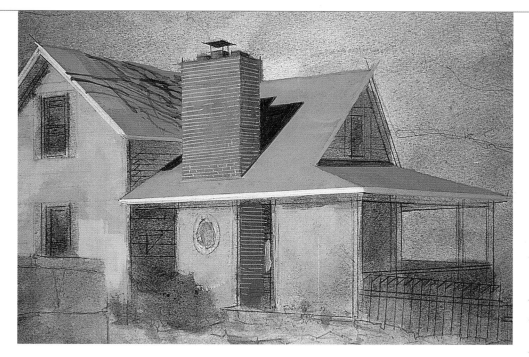

3 Paint the Roof and Chimney

Because of their prominence in the composition, start your opaque applications by painting the roof and the chimney. Lay in the roof using your 1-inch (25mm) flat and a mixture of Burnt Sienna, Ultramarine Blue, Alizarin Crimson and gesso. Use your no. 4 round and a straight-edge to paint around the edges. Still using your 1-inch (25mm) flat, paint the chimney with a mixture of Burnt Sienna, Ultramarine Blue and gesso. Again, keep the edges clean by using a straightedge and your no. 4 round. Create the brick joints in the chimney using your no. 4 round and a light gray mixture of Burnt Sienna, Ultramarine Blue and gesso. Add shadows cast onto the roof by the chimney and tree limbs using a darker mixture of the roof color. Apply the tree limb shadows using your no. 2 liner and the chimney shadows using your no. 4 round. Add more Ultramarine Blue to those shadows you want to appear cooler.

87

4 Paint the Sky and Background Trees

Using your ½-inch (13mm) flat and a mixture of Burnt Sienna, Ultramarine Blue and gesso, paint the background trees. Make the trees at the horizon a cool blue-gray color to suggest distance. Use more Burnt Sienna to paint the trees near the middle ground, making them appear closer. Add more blue to your mixture and lighten it with gesso. Using your ½-inch (13mm) flat, apply this light blue mixture to the sky. To avoid creating a hard edge where the trees and sky meet at the horizon, quickly brush the sky strokes near the top of the trees with a near-dry brush. The resulting texture will be broken and thus soften the edge.

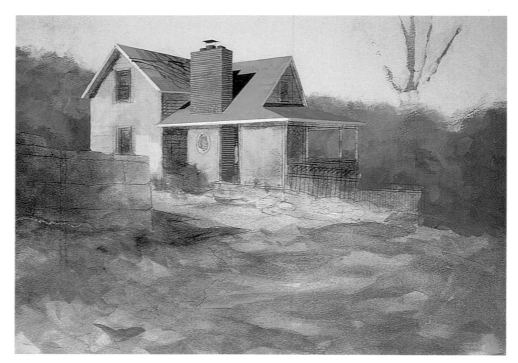

5 Finish the House

Using your no. 4 round and gesso warmed with a bit of Yellow Ochre, paint the house. This application serves as the base color. To indicate shaded areas add some of the gray used to create the background trees in step 4. With your straightedge paint the clean, straight lines in the lattice, columns, fascia and fence using your no. 4 round and gesso diluted slightly with a mixture of water and matte medium. Still using your straight edge, indicate the siding on the house with your no. 4 round and a mixture of Burnt Sienna and Ultramarine Blue. To create a weathered look, glaze the house and fence with a transparent gray and a bit of Alizarin Crimson diluted with matte medium. Don't overdo this—it only takes a very light glaze to give the desired effect. Darken the glass area of the windows with some of the existing gray mixture, and add a bit of Cerulean Blue to paint the shutters and the circular trim on the lattice.

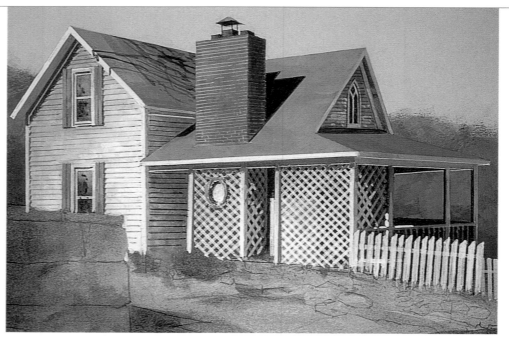

6 Establish the Roadway

Apply the base color to the roadway with your ½-inch (13mm) flat and various mixtures of Burnt Sienna, Ultramarine Blue and gesso. The roadway should be lightest near the house and get progressively darker and cooler as it moves away from the house. To create the foreground shadows, darken the mixture with Ultramarine Blue and apply strokes with your no. 4 round. Next, splatter the roadway to suggest its rough texture using your 1-inch (25mm) flat and various mixtures already on your palette. Using the same mixtures and your no. 4 round, apply a few final highlights. For variety and temperature change, add several more highlights with a mixture of Ultramarine Blue and gesso. Finally, place a light glaze of Yellow Ochre diluted with matte medium over the roadway near the entry of the house, indicating sunlight.

7 Add the Grass and Leaves

Begin this step by indicating the small shadows cast by the fallen leaves to the left of the roadway. Paint these shadows with your no. 4 round and the darker mixtures used to paint the roadway in step 6. Then place leaves and grass among these shadows using your no. 4 round and Burnt Sienna muted with the grays already mixed on your palette. Add highlights to the leaves using Burnt Sienna lightened with gesso. Place several random strokes of the Burnt Sienna mix inside and on the right side of the roadway. These will look like blown leaves and will visually soften the gray roadway.

8 Paint the Stone Wall

Add the stone wall using the same gray mixtures that you've already mixed on your palette. Just like the roadway, the stone wall should be lightest near the house and get progressively darker and cooler as it moves away from the house. Use your ½-inch (13mm) flat to block out the basic shapes and colors of the wall. Then using your no. 4 round, add the dark gray joints between the individual stones and place small gesso highlights on several of the stones. These highlights echo the white in the house and serve to unify your composition. At this point, you may reinforce the shadows in the roadway cast by the wall if necessary, using the gray mixtures already on your palette.

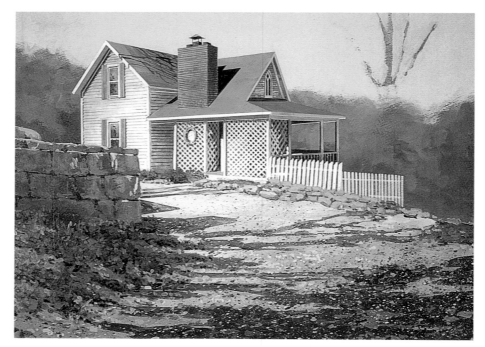

9 Paint the Middle Ground, Foreground Trees and Complete Fence

While the gray mixtures on your palette are still soluble, use your no. 4 round to add the middle ground and foreground trees. Paint those trees farthest away and the smaller, finer limbs of the closest trees using your no. 2 liner. Make the most distant middle ground trees (as shown in the lower left of this detail) only slightly lighter than the background. Overlap the limb structure of the closest trees with those behind them, creating the illusion of depth. Increase the amount of detail on the trees, including gesso highlights, as the trees get closer. Vary the value and color of the trees slightly in order to avoid monotony. Then finish painting the fence, adding the final section that is farthest from the house with your no. 4 round and gesso thinned with water and matte medium. Notice that the posts get increasingly smaller and lighter as the fence stretches into the distance.

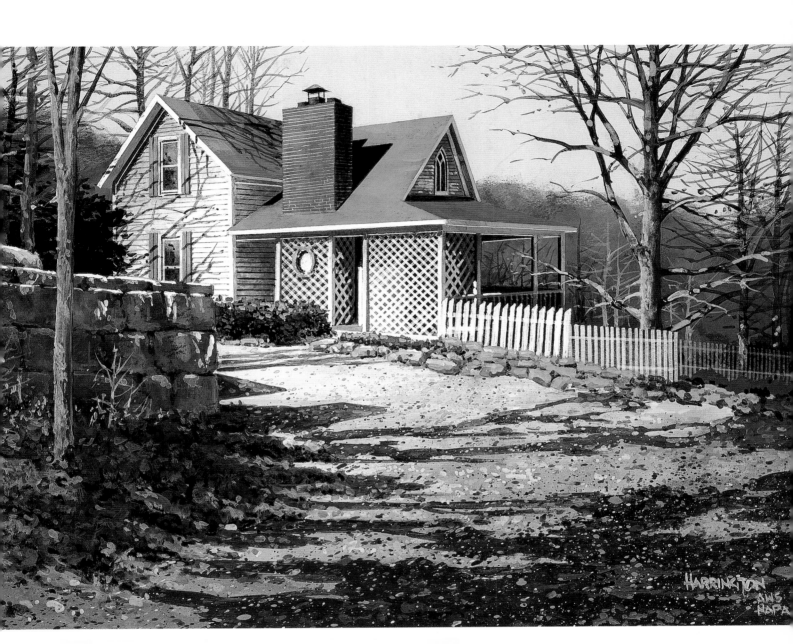

EUREKA SPRINGS HOUSE
300-lb. (640gsm) cold-pressed watercolor paper / 10" x 14" (25cm x 36cm)

10 Add Final Touches

After you have finished the trees and fence, add the green trees and shrubs to the left of the house, at the base of the house and in the distant right using your no. 4 round and various mixtures of Hooker's Green Deep and gesso. Add shadows cast by the tree limbs onto the side of the house with your no. 2 liner and a mixture of Burnt Sienna and Ultramarine Blue. If you see passages that don't seem to work, remember that most, if not all, of your painting is opaque. This means that you can easily paint over areas, making any changes that you feel are appropriate.

Painting on a Canvas Support

Materials

Surface
Gesso-primed linen
 canvas (18" x 24"
 [46cm x 61cm])

Brushes
No. 2 liner
Nos. 4 and 8 rounds
1-inch (25mm) flat

Acrylics
Burnt Sienna
Hooker's Green Deep
Ultramarine Blue
Yellow Ochre

Other Supplies
Flow release
Gesso
Hair dryer (optional)
Masking fluid
Matte medium
Sketching materials
Spray bottle

Numerous times I've been asked whether or not it is possible to paint with transparent acrylics on grounds other than paper. This question is usually motivated by a desire to frame and display paintings without having to protect them with glass as is required for works on paper. The answer is yes—acrylics can be used on a variety of supports, including canvas, as long as you properly prime the support for acrylic applications. In this demonstration you will use a prestretched linen canvas primed with acrylic gesso as your painting ground.

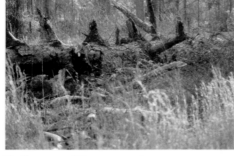

Reference Photograph
I discussed my attraction to this old tree in chapter two. I have selected it as the subject for this demonstration because it is relatively easy to draw and it provides a variety of compositional and textural possibilities. Local colors available in its winter setting suggest a limited color palette.

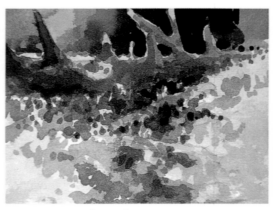

Compositional Study
Because the reference photograph does not represent an especially good composition, I had to make some design decisions. I created this compositional study on a small piece of watercolor paper using my no. 4 round and the colors on the palette. Remember, when making your own compositional study, avoid the temptation to add details. Concern yourself only with shapes, values and colors. Design decisions made here will help you avoid indecision and possibly bad decisions while you are in the middle of the painting.

Eliminate or Emphasize
You must develop the ability to eliminate the nonessential details and emphasize the primary subject of your painting.

92

1 Complete Drawing and Lay Initial Washes

Transferring a drawing to a stretched canvas can be difficult because the surface flexes when you apply pressure. Thus, I suggest that you construct your drawing directly on the canvas with a graphite pencil. As a minimum, draw enough to define the primary shapes in your composition. Beyond this, draw as much detail as you consider appropriate. Most of the graphite lines will disappear under layers of paint as you execute the painting. After your drawing is finished, wet the surface of your canvas using your 1-inch (25mm) flat and apply a light wash of Yellow Ochre. This will subdue the white of the canvas and give a warm, sunlit glow to the painting. Again, allow your paper to dry between all paint applications.

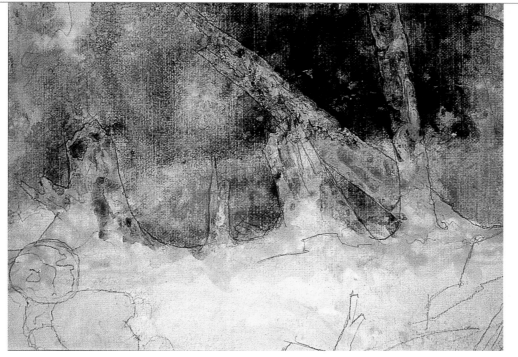

2 Lay in Background Colors

Mask off the top part of the fallen tree with masking fluid. On your palette, prepare separate puddles of Burnt Sienna, Ultramarine Blue and Hooker's Green Deep for the background foliage. Using a clean, damp 1-inch (25mm) flat, wet the background area of your canvas. With the same brush, apply each of the colors separately, allowing them to mix on the canvas. Paint quickly, being careful not to overwork the colors with your brush. Use your spray bottle to keep hard edges from appearing. Allow all applications to dry, repeating this process until you're satisfied with the results. Monitor each application carefully during the drying process, keeping a damp no. 8 round ready to lift unwanted puddles of water or paint that is going astray.

3 Remove Masking and Add Grassy Strip

After the canvas is dry remove all masking fluid. Next, add the grassy strip between the top of the fallen tree and the background foliage using your no. 4 round and Yellow Ochre. This strip of grass serves as a visual break between the background foliage and the debris in the middle ground. It is important to keep the strip as light as possible so it contrasts with the dark background colors.

4 Lay In Middle and Foreground Shapes

After the canvas is dry, remove all masking fluid. Establish the shape and basic value of the tree and fallen limbs in the middle ground and foreground. Begin by applying a light wash of Yellow Ochre to the tree and limbs. Further define these shapes with your nos. 4 and 8 rounds and a combination of Burnt Sienna and Ultramarine Blue. Remember not to overmix. Allow the colors to mix on the canvas, avoiding the temptation to overwork the applications with your brush. Using the same brushes and paint mixtures, apply the dark areas in the foreground grass. Then, with your 1-inch (25mm) flat and the varying mixtures of Burnt Sienna and Ultramarine Blue currently on your palette, lightly splatter some texture on the fallen tree and foreground grass.

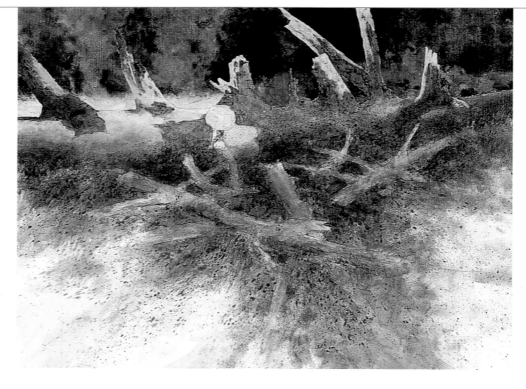

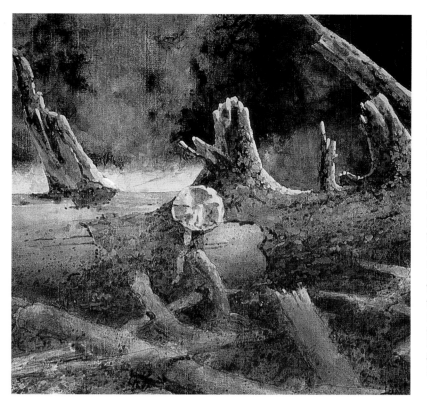

5 Detail Fallen Tree

With your no.4 round and a transparent mixture of Burnt Sienna and Ultrramarine Blue, begin deffining detail in the fallen tree. The most significant details are the splintered ends of the broken limbs and the texture of the bark. The small, dark shadows withing hte bark texture and at the edge of the bark give the illusion of a third dimension. For the translucent and opaque highlights, mix gesso with your paint mix. The opaqueness of the mix will depend on hte amount of water/Matte Medium you use in the mix. With your no. 4 round, apply the yellow highlights with a mixture of yellow Ochre and gesso. The blue-gray highlights on the bark will require a mix of Burnt Sienna, Ultramarine Blue and gesso.

Putting it in Perspective

Looking at the full painting, you can see the importance of the highlights on the top edge of the tree. If the opaque highlights get a little too blue, they can be muted later with a thin transparent glaze of Burnt Sienna.

The contrast between the highlights on the top edge of the fallen tree and the dark background helps to establish the primary focal point.

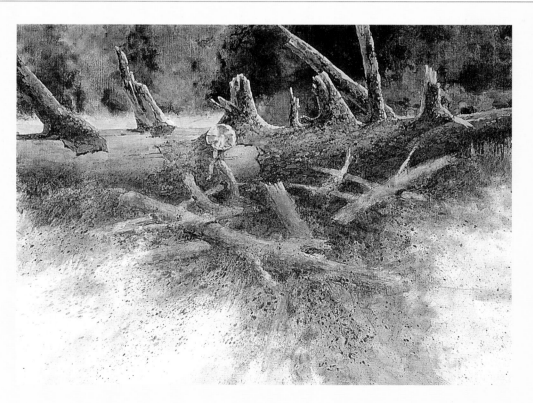

6 Define Background Foliage

Assuming that you have made the background foliage dark enough, it is almost complete. Add some definition of tree structure that will establish scale and add the perception of distance. Add some gesso to your Burnt Sienna and Ultramarine Blue mix. The resulting color should be neutral and a bit lighter than you want it to appear in the finished painting. Use your no. 2 liner to construct the distant tree trunks. Vary the value of your mixture, depending on how dark or how light the background foliage is. After you are satisfied with the structure, use your no. 4 round to apply transparent glazes of Burnt Sienna and Ultramarine Blue to the opaque strokes. This allows you to adjust the value and color and gives a transparent look to the opaque application.

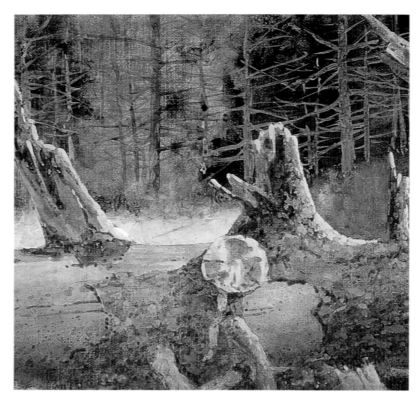

7 Finish Foreground Details

Finish detailing the broken limbs in the foreground, using your no. 4 round and a mixture of Burnt Sienna, Ultramarine Blue and gesso to apply bark texture. Add a few lighter, blue-gray highlights to provide color change and to unify these objects with the tree trunk. Then with the same brush and a mixture of Yellow Ochre and gesso, add yellow highlights to the limbs. Create texture in the foreground grass using the same yellow mixture. Add just enough water to make the paint fluid. Use your no. 2 liner to paint a network of primarily vertical strokes. Remember, you're painting grass; therefore, the gesture of the strokes should be in the direction that the grass normally grows. To avoid monotony, vary the spacing, weight and direction of these strokes.

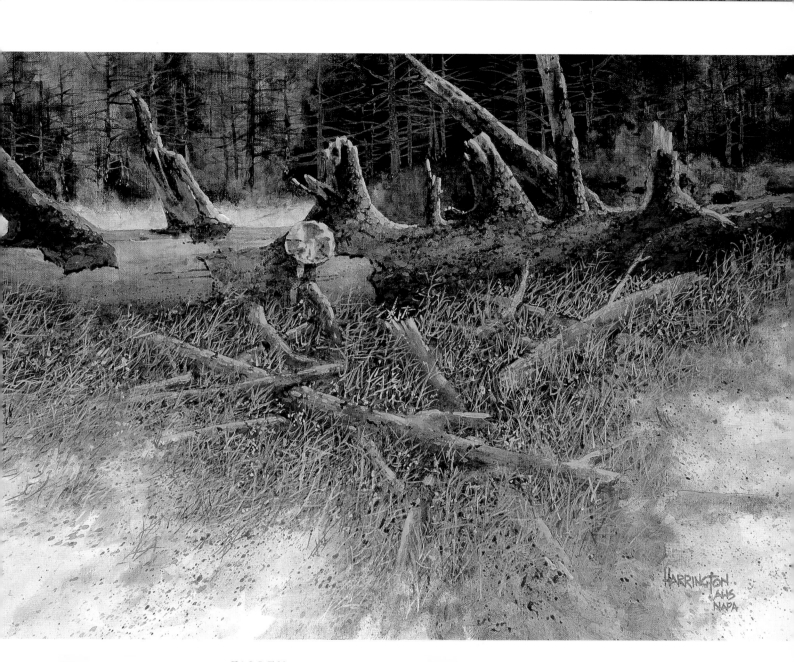

FALLEN
Gesso-primed linen canvas / 18" x 24" (46cm x 61cm)

8 Add Final Touches

Look at your finished painting to make sure that all components work well together and that you haven't missed any critical detail or highlights. If your highlights appear too blue at this point, mute them with another transparent glaze of Burnt Sienna. You may also add additional splatter in the foreground to heighten the sense of texture using your 1-inch (25mm) flat and mixtures of Burnt Sienna and Ultramarine Blue.

Working on Gesso-Primed Panel

Materials

Surface
Masonite panel (16" x 20"
 [41cm x 51cm])

Brushes
No. 4 round
½-inch (13mm) and
 1-inch (25mm) flats

Acrylics
Alizarin Crimson
Burnt Sienna
Ultramarine Blue
Yellow Ochre

Other Supplies
Flow release
Gesso
Hair dryer (optional)
Masking fluid
Matte medium
Sketching materials
Spray bottle
Straightedge

As you already know, acrylics can be applied to a variety of supports. If cost of materials is an issue, a Masonite panel primed with gesso provides an attractive alternative to paper. It is by far the least expensive support used in these demonstrations. And, like canvas, Masonite primed in this fashion can be framed without the usual mats and glass required for works on paper, saving you additional money. What's better, the economical nature of Masonite doesn't mean it's poor quality. In fact, if properly primed, Masonite will prove an archival-quality support for your paintings. Acrylics in both transparent and opaque modes adhere well to the gessoed ground of the panel, resulting in unique, durable and attractive textures. This demonstration gives you an opportunity to try your transparent acrylic techniques on this exceptional painting support.

Reference Photograph
There are times when you simply don't feel inspired to paint a building or a landscape. And sometimes, for the sake of variety, you would just like to paint something different. At these times a good alternative is to set up a still-life arrangement of familiar objects. An old pair of purple tennis shoes that were always lying around wherever my teenage son last pulled them off inspired the still-life in this demonstration.

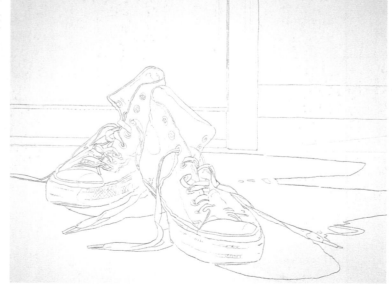

1 Complete Drawing
Work out the subtleties of your composition in a full-scale drawing on tracing paper. Graphite smears more easily on gesso ground than it does on paper, so drawing directly on the gesso ground might get messy. If you choose to draw directly on the panel, keep in mind that graphite lines and smudges will be visible through transparent paint applications. Once you are satisfied with the drawing, transfer it to your Masonite panel using graphite transfer paper.

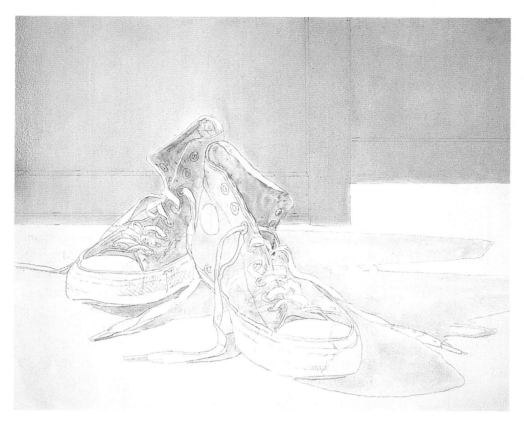

2 Apply First Washes

With your 1-inch (25mm) flat apply a very light wash of Yellow Ochre to your panel, concentrating on the carpet area. Using the same brush, also apply light washes of color to the shoes, shadow and wall shapes. Mix the cool gray for the wall with Burnt Sienna and Ultramarine Blue and the purple for the shoes with Ultramarine Blue and Alizarin Crimson. Remember, for applications on a gesso ground your paints should always be thinned with a 50/50 mix of water and matte medium. Also add a couple of drops of flow release to each mix. This procedure will improve the handling characteristics of your paint and will allow you to get a more consistent coverage of the ground surface. Once again, allow all applications to dry before moving on.

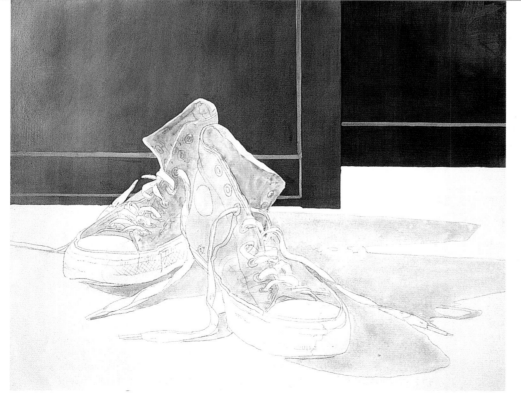

3 Paint the Background Wall

Cover the top edges of the shoe and the bottom edge of the wall with masking fluid. This will allow you to apply paint without concern for maintaining these critical edges. Using your 1-inch (25mm) flat, dampen the surface of the background wall. With the same brush, apply consecutive glazes of Ultramarine Blue, using your spray bottle as needed to keep the surface wet while applying paint. Allow the surface to dry after each glaze. For the recessed portion of the wall, mute the blue with a small amount of Burnt Sienna. Then, lighten the muted blue on your palette with gesso, using this mix, your no. 4 round and your straightedge to apply the linear highlights on the wall. Let this dry.

4 Paint the Shoes

Mask the strings, eyelets and the outer edge of the shoes with masking fluid. Paint the purple body of the shoes using your ½-inch (13mm) flat and a mixture of Ultramarine Blue and Alizarin Crimson. Allow this to dry and remove all masking fluid. Then, with your no. 4 round and a mixture of Burnt Sienna and Ultramarine Blue, paint the shadows inside the shoes and on the soles and strings. After you have defined these basic shapes, apply a light glaze of Yellow Ochre to the shadows. This creates the illusion of warm reflected light and will enhance the worn look of the shoes.

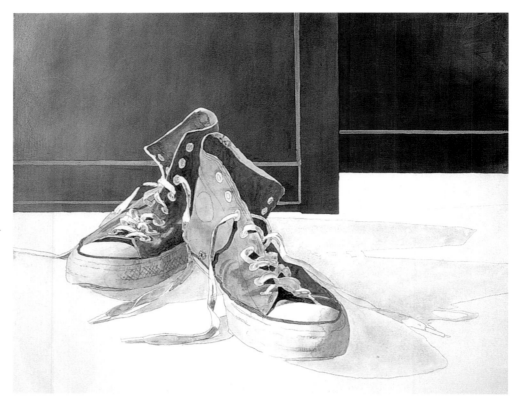

5 Suggest Carpet and Paint Shadows

Protect all areas of your painting, with the exception of the floor, using either masking fluid or pieces of scrap paper. Then, using your 1-inch (25mm) flat and a well-diluted mix of Burnt Sienna and Ultramarine Blue, splatter the floor area to suggest carpet. Don't overdo the texture, taking care to keep it light and consistent. Next, mask the edges of the shadows cast by the background wall and the shoes with masking fluid. These shadows should have rough edges and follow the contour of the carpet, so be sure to mask the edges in a broken, irregular line to further create the illusion of texture. Paint these shadows with a mixture of Burnt Sienna and Ultramarine Blue using your ½-inch (13mm) flat. Place warm and cool variations within the shadows by varying the color mix.

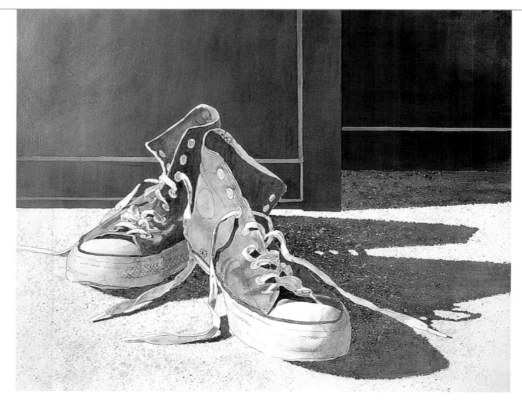

6 Add Detail to Shoes

Using your no. 4 round and a mixture of Burnt Sienna and Ultramarine Blue, shape the shade and shadows in the shoestrings and add the embossed patterns on the side of the shoe soles. Use a cool gray mix of Burnt Sienna and Ultramarine Blue to paint the eyelets. Then add the highlights on the eyelets and the stitching using your no. 4 round and white gesso.

Taking a Closer Look

Take the time to make sure your shadow colors and values are accurate, adding a few lighter highlights to the shadows if necessary. To do this, use your 1-inch (25mm) flat and splatter an opaque gray mixture into the shadows. As with the previous splatter application, be careful to mask or protect those areas that you don't want affected by this application.

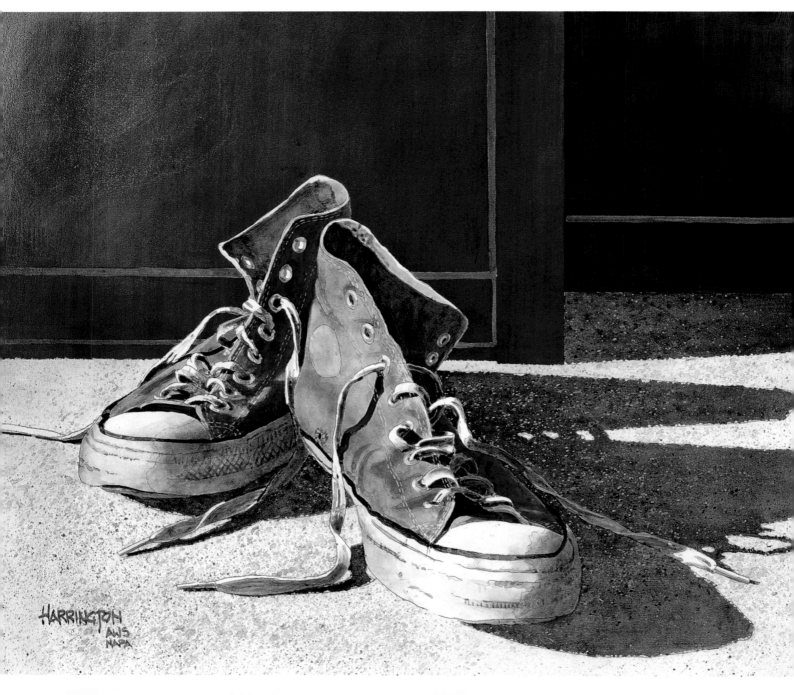

CONVERSE
Gesso-primed Masonite panel / 16" x 20" (41cm x 51cm)

7 Add Final Touches

Fine-tune highlights with your no. 4 round and opaque mixtures as needed. Add a bit of Yellow Ochre to gesso for the highlighted portion on the top edge of the shoes. Use white gesso to recover any small, light highlights that have been inadvertently painted over, then repaint these areas with appropriate colors.

Using Absorbent Ground

Materials

Surface
Watercolor canvas
(16" x 20" [41cm x
51cm])

Brushes
No. 4 round
½-inch (13mm) and 1-
inch (25mm) flats

Acrylics
Burnt Sienna
Cadmium Yellow
Medium
Cerulean Blue
Hooker's Green Deep
Ultramarine Blue
Yellow Ochre

Other Supplies
Absorbent ground
(if canvas doesn't
come primed)
Gesso
Hair dryer (optional)
Masking fluid
Sketching materials
Spray bottle

To accommodate artists who don't want to deal with the limitations of paper but still want their paintings to look like they were created on paper, manufacturers have marketed a product known as absorbent ground. Applying absorbent ground to any gesso-primed support will give it the the absorption quality of paper without compromising its archival integrity. In other words, you can achieve the look and feel of a transparent watercolor done on paper without having to worry about framing your painting under glass.

For this demonstration we will use a watercolor canvas. I recommend the Fredrix brand, since it comes already primed with absorbent ground. If you purchase a canvas that isn't already primed, make sure you prime the canvas with gesso first and then apply several coats of absorbent ground.

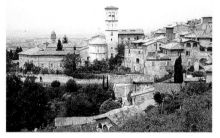

Reference Photograph
An Italian hill town, Assisi, is the subject for this demonstration. Its ancient architectural forms appear to be cascading down the steep hillsides, and they possess a patina that can only come from having stood for hundreds of years. Before starting your drawing, study the subject carefully. Try to get into the spirit of the place. Imagine St. Francis of Assisi walking these streets more than seven hundred years ago.

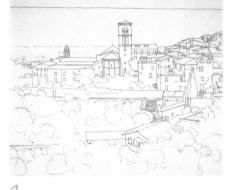

1 **Complete Drawing**
Because the subject matter is fairly complex, work it out in a full-scale drawing on tracing paper. After you are satisfied with the accuracy of the drawing, transfer it to your canvas using graphite transfer paper.

2 **Paint the Sky**
Mask the top edge of the buildings with masking fluid so you can paint the sky and background without concern for painting into the buildings. Prepare a translucent mix of Cerulean Blue, Cadmium Yellow Medium and gesso. After dampening the sky and background area with a fine spray bottle, use your 1-inch (25mm) flat to apply a uniform wash of this mixture. Note that it may take more than one application to get complete coverage. Let your paper dry in between all paint applications.

3 Paint the Distant Background

Add a bit more Cerulean Blue to the mix currently on your palette and paint the distant tree shapes using your no. 4 round. Create a sense of distance by getting lighter and closer to the sky color as you near the horizon line. Create the lighter patches in the landscape by adding more gesso to the paint mixture. Paint a few tile rooftops with a mixture of Burnt Sienna and gesso. Do not overdo the detail here. You can always add more detail later if needed.

4 Rough in Trees and Buildings

Remove the masking from the buildings and apply fresh masking fluid to the outside edges of the buildings. Using your 1-inch (25mm) flat, apply a mixture of Burnt Sienna and Ultramarine Blue to the buildings. This will represent the lightest value on the finished buildings. Don't overmix the paint on your palette. Allow the colors to blend on the canvas. Still using your 1-inch (25mm) flat, rough in the tree shapes with Hooker's Green Deep. Although at this point you are simply roughing in the shapes and covering the white of the canvas, try to accurately define the edges of the green against building forms. Allow this to dry.

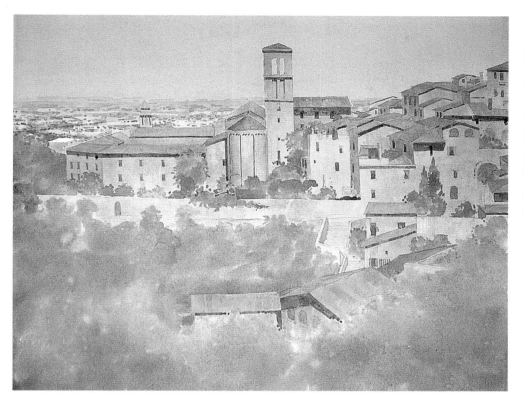

5 Add Details to Buildings

Apply a wash of Burnt Sienna to the rooftops of the buildings using your ½-inch (13mm) flat. Slightly exaggerate the color of the red tile to create visual interest within the painting. Add Ultramarine Blue to the Burnt Sienna mix and paint the window recesses and other shaded details on the buildings. Your no. 4 round will work well for these small shapes.

6 Refine Roof Tiles

Use the "Painting Straight Lines" technique on page 52 to add texture to the roof tiles with your no. 4 round and Burnt Sienna mixed with a touch of Ultramarine Blue. Add gesso to Burnt Sienna to paint the lighter highlights. Then with your ½-inch (13mm) flat, shade the roof planes that are facing away from the light source with a pale wash of Ultramarine Blue. Use the same light blue wash to darken selected roof planes.

7 Define Tree Shapes

Using a no. 4 round and Hooker's Green Deep, define the shade and shadows in the foreground and middle ground trees. Add just enough detail to the trees to suggest their individuality without visually breaking up the larger shapes. Given their forward location in the composition, it would be easy for the trees to dominate and thereby upstage the buildings, so don't overdo the detail. Add a little color variety by highlighting a few of the trees with a light glaze of Cadmium Yellow Medium.

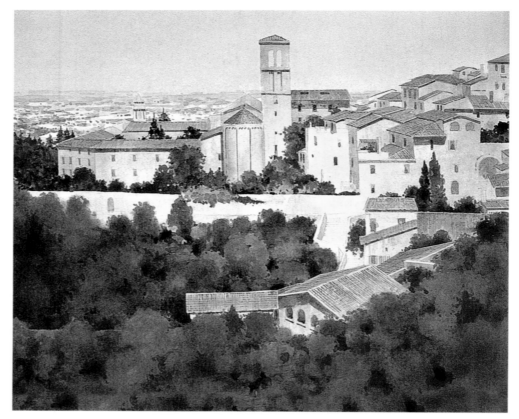

8 Finish Detailing Buildings

The buildings are the primary subjects of this painting; therefore, they should be the most detailed objects in your composition. Use your no. 4 round and an opaque mixture of gesso and Yellow Ochre to paint the lightest highlights on the buildings, including a few stones in the vertical walls, the trim around windows and fascias on the sunlit side of the building. Add a few darker stones in the vertical walls using a light mix of Ultramarine Blue. This variety will enhance the aged appearance of the walls. Remember, these buildings are ancient.

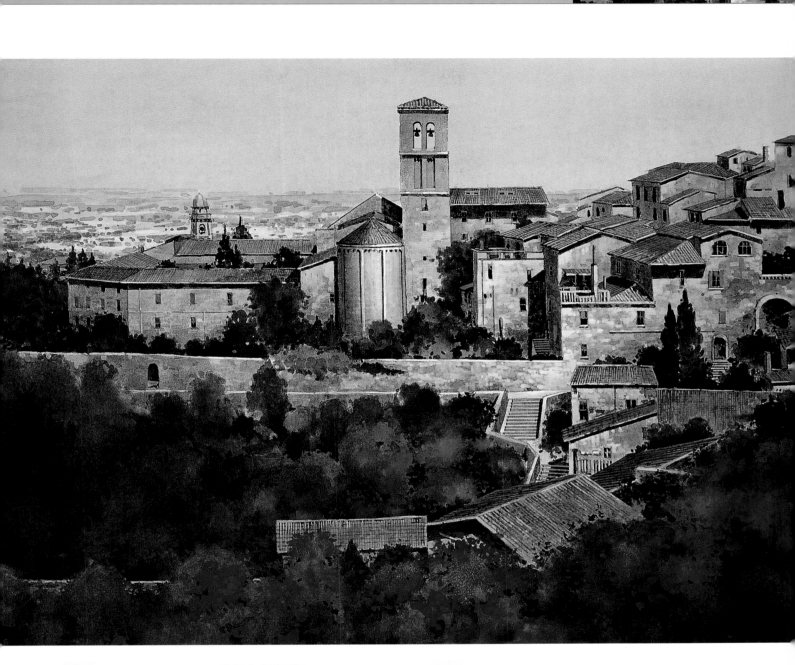

HILL TOWN
Fredrix watercolor canvas / 16" x 20" (41cm x 51cm)

9 Add Final Touches

As a final step, add a few finishing details. These are especially needed in the foreground trees. Prepare an opaque mixture of Hooker's Green Deep, Cadmium Yellow Medium and gesso. With this mixture and your no. 4 round, add more texture to the trees. Darken or lighten the paint mixture until it matches the existing green when dry. Viewing the painting as a whole at this point, I decided that the windows in the foreground building attracted too much attention. Remedy this by covering the windows with foliage using your no. 4 round and the green mixture currently on your palette.

Reworking Failed Passages

Materials

Surface
300-lb. (640gsm)
 cold-pressed
 watercolor paper

Brushes
No. 4 round
½-inch (13mm) and
 1-inch (25mm) flats

Acrylics
Alizarin Crimson
Burnt Sienna
Cerulean Blue
Hooker's Green Deep
Ultramarine Blue
Yellow Ochre

Other Supplies
Gesso
Hair dryer (optional)
Masking fluid
Sketching materials
Spray bottle
Straightedge

Oops! This painting didn't turn out as well as I had visualized. Does this scenario sound familiar? We've all been there. Whether the problem is poor painting technique or poor design decisions, the result is the same—a painting you're not pleased with. The question is do you hastily send the painting to the reject pile or attempt to save it by making a few changes or additions?

In order to demonstrate the use of acrylics to save a failed painting, you'll be examining one of my rejects. The painting techniques and applications are good; however, it needs some significant compositional changes. At this point, acrylics offer you more options than traditional watercolor. I'll take you through the process step-by-step as I rescue my painting from the trash.

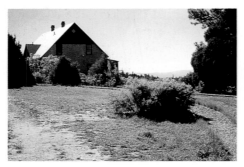

Reference Photograph
The subject of my painting was a ranch house near Taos, New Mexico.

Original Compositional Study
In this small marker sketch I attempted to simplify the composition and focus more attention on the ranch house. I placed the face of the house in full sunlight and attempted to contrast this with dark foliage at the left and in front of the house. Trying to visually balance the composition, I continued the dark value in the distant trees and mountain and placed a large cloud formation in the upper right quadrant of the composition.

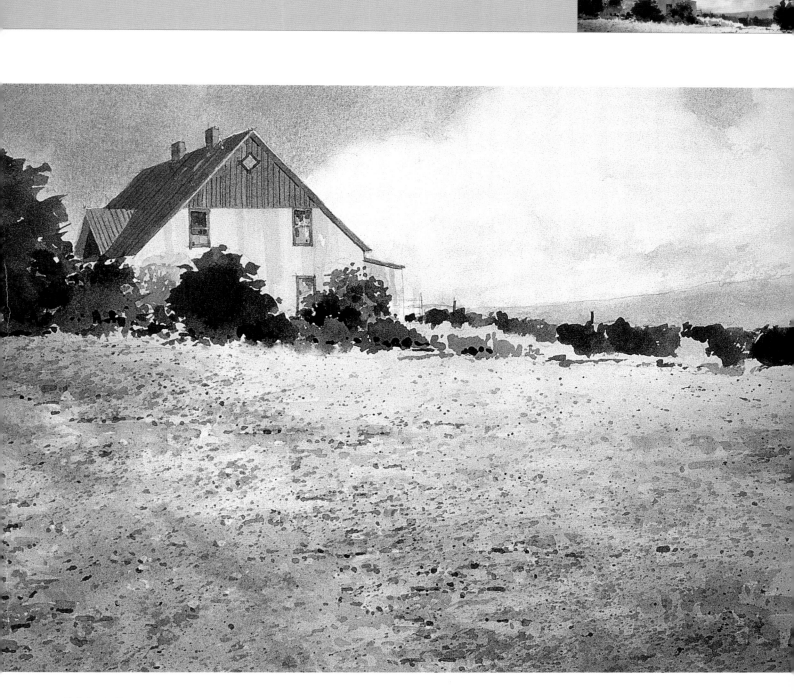

Original Finished Painting

The finished product may be satisfactory in terms of technique and color application, but several design problems hinder this painting from being successful. For example, the visual path is weak and encourages the viewer's eye to exit the painting prematurely. There is also a problem with the balance of this composition, as there is nothing on the right to counterbalance the weight of the house on the left. This lack of equilibrium is both visually distracting and unappealing. Moreover, because everything in the composition is in the sunlight, the painting lacks the proper interplay between light and shadow. Adding more shaded areas would create sharper contrast and evoke a more interesting mood.

Had this painting been done in watercolor, the long list of deficiencies might lead one simply to throw it out with the trash. However, due to the versatile nature of acrylic paint, we can alter elements and correct mistakes, saving this painting from the reject pile.

5 Add Tree and Foreground Foliage

In order to improve visual balance, add a tree shape to the right side of the composition using your ½-inch (13mm) flat and Hooker's Green Deep. With the same brush and color, add the bush in the foreground. Then mix gesso and a bit of Yellow Ochre to the Hooker's Green Deep, using this mixture and your no. 4 round to create the highlights on the bush.

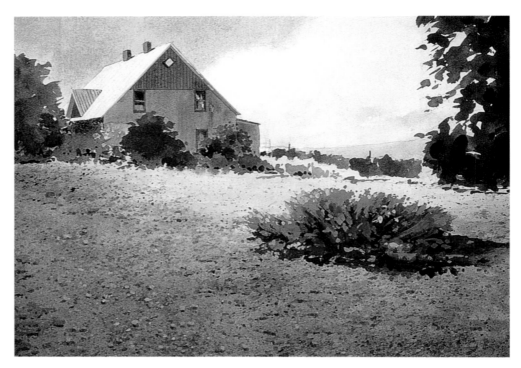

6 Darken the Sky

Since the overall tone of the painting has become darker, the blue sky is too light to uphold its part in the composition. Correct this by adding another application of Cerulean Blue, the initial color used to paint the sky. Begin by masking the top edge of the house with masking fluid. Then, wet the sky with your 1-inch (25mm) flat and clean water, immediately following this with an application of Cerulean Blue. The moist paper will allow you to keep the edge between the blue sky and the white clouds soft. While the paper is still damp, add more definition to the bottom of the clouds using a mixture of Cerulean Blue and Alizarin Crimson. Let your paper dry, then remove the masking promptly.

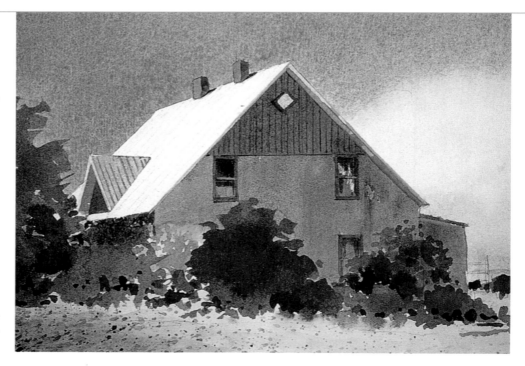

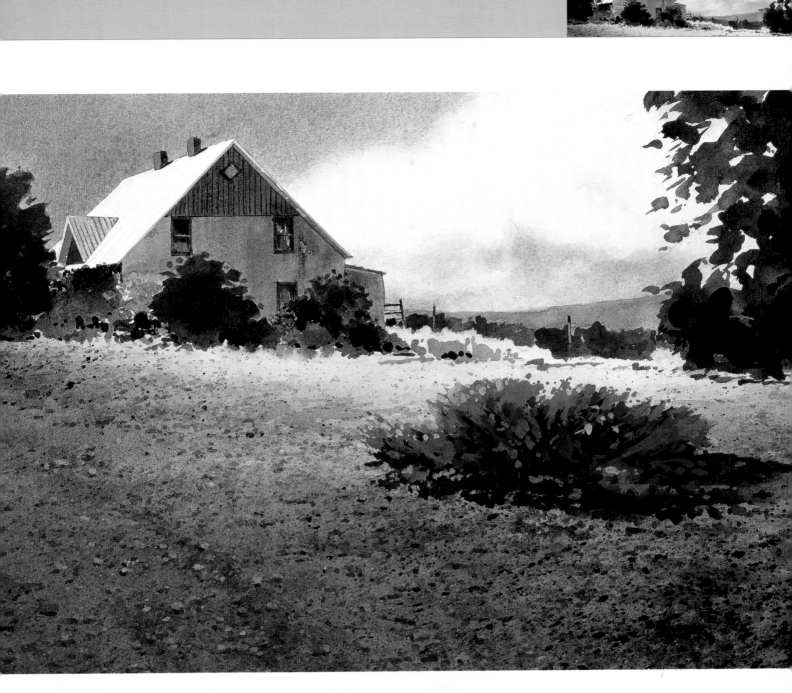

HIGH PLAINS RANCH HOUSE
300-lb. (640gsm) cold-pressed watercolor paper / 10" x 14" (25cm x 36cm)

7 **Add Final Touches**

Now that all of the pieces of the revised composition are in place, give one last critical look at how they all relate to each other and make a few final adjustments. After wetting the foreground, darken the shadow a little more by applying another light wash of Ultramarine Blue warmed slightly with Alizarin Crimson. Again, be careful to maintain the sunlit area near the house. Splatter a little more dark texture in the lower right-hand corner of the composition using your 1-inch (25mm) flat and Hooker's Green Deep. Then, with your no. 4 round and a mixture of Cerulean Blue and Alizarin Crimson, darken the distant mountain slightly. Voilà! Just like that you've successfully transformed a rejected painting into a much-improved keeper. Congratulations!

Presenting Your Work

You may think that once you've completed your painting that you're work is finished. However, the design process doesn't end when you put the last stroke of paint on your painting. The presentation of your work also requires thoughtful design decisions. Whether displayed on a wall in the home of a proud new owner or in a gallery in hopes of attracting a buyer, someone will make decisions about how your painting should be matted, framed and displayed. If hanging in your own studio or on showcase at an exhibition, you, the artist, will have aesthetic control over these display options.

Paintings on paper have traditionally been matted and framed under glass. The glass protects the mat and the painting from damage by environmental contaminants. Because acrylic paintings on canvas or rigid panels do not need to be protected by glass, mats are seldom included in the framing process. However, in this case the frame often includes a linen covered liner that provides a visual break between the painting and the frame. The liner serves the same aesthetic purpose as a mat.

Of course the ideal scenario is to hire a professional framer to mat and frame your paintings to your specifications. If this option is not economically feasible or if you simply enjoy doing your own matting and framing, you will need a few appropriate tools. Cutting your own mats is the easiest part of this process. You will need mat boards and a mat cutter. I use an Alto's 4505 Mat Cutter, which is available from most artist's materials suppliers. With instructions that come with the cutter and an hour of practice, you can confidently cut your own mats.

The next step toward independence from the professional framer is to purchase prefinished frame molding and build your own frame. For this you will need tools capable of cutting an accurate mitered corner and clamps to hold the pieces together while you secure them with glue and nails. A quick Internet search will locate sources for a variety of moldings, framing tools and numerous tutorials illustrating the how-to's of cutting and joining frames.

The ultimate challenge to the do-it-yourself framer is to make and finish your own molding. This can be a much more time-intensive effort. The tools and materials can be relatively simple and inexpensive; however, the learning curve is another issue. Finishing frame molding is an art in itself. It can range from a simple clear coating on a beautiful piece of wood to hand gilding with gold leaf. Most artists don't have the time to make and finish picture frames. For those who do, though, it can be a fun and rewarding experience.

Mat and Frame Selection

There is no universal method for matting and framing your painting—the choice is ultimately yours.

However, keeping the following suggestions in mind may be helpful as you make your decisions:

- Remember that your primary objective is to show your painting at its best.
 Anything that does not support that objective is probably not in your best interest.
- Colored mats and heavily ornate frames often upstage your painting.
 Your painting, not the frame or mat, should be the star of the show.
- Although you should be aware of popular trends in framing styles, be wary of fads and gimmicks.
 If your artwork is good enough to stand on its own merit, it will not need a gimmick or a crutch.

A Framed and Matted Painting

Most of my paintings on paper are triple matted with three- to four-inch (8cm to 10cm) wide, off-white mats cut from Crescent board. The exact width of the mat depends on the size of the painting. The matted painting is then set in a simple wood frame. Within this composite, the viewer's eye goes directly to the painting with little, if any competition from the mat and frame. It is for this reason that most quality watercolor exhibitions specify an off-white or light gray mat and a simple frame as a condition for submission of works. Years of experience have proven this to be the most effective way to maximize the visual impact of a painting.

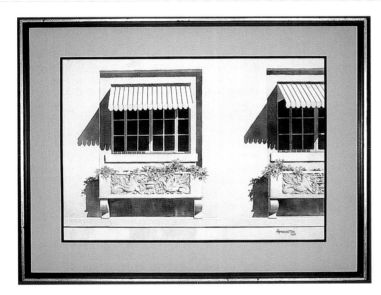

Another Example

Because this painting is predominantly white with very little color, it would not read well against a white mat. Similarly, a colorful mat would prove a bad choice, as it would likely upstage the painting, overwhelming its subtle colors. I used a light gray mat set in a thin black and silver frame. A ¼-inch (7mm) liner was placed between the painting and the mat, defining the edge of the painting and echoing the black frame. The combination of black, silver and gray in this frame and mat presents little competition for the subtle colors in the painting and complements the composition nicely.

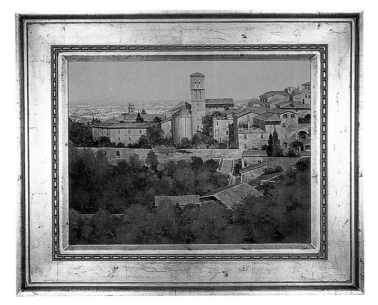

Framing Canvas and Panels

Because of the elimination of the mat and the glass, a painting on canvas or rigid panel requires a different type of frame. This example shows a canvas framed in a gold readymade frame. These frames are popular because they come in sizes that accommodate standard size, readymade canvases. Since they are imported, they are usually less expensive than comparable custom-made frames. A quick Web search will net you several sources of readymade frames. Although this particular frame attracts more attention to itself than previous examples, its simplistic nature, uniform color and pleasing proportions make it an elegant setting for the painting. Many of these frames include a thin linen-covered liner next to the painting. This is often desirable as a visual break between the frame and the painting. Canvas and panels can also be effectively framed with wide linen-covered liners, simulating the aesthetic of a thinner frame and mat combination used to frame works on paper.

Photographing Your Work

Many experienced painters lament the fact that they have not been diligent enough in keeping a good photographic record of their work. After it is sold or otherwise leaves your control, it is often impossible to get the access necessary to take quality photographs of your work. Systematic photographing of each painting as you finish it is the only way to avoid regrets later.

Although an arrangement with a commercial photographer or qualified friend will work, it is not always convenient. The inconvenience of having to depend on someone else and the expense of professional photography are just two of the reasons an artist may want to photograph his or her own work. However, taking quality photographs doesn't necessarily come naturally to all painters. Thus, before wasting a great deal of energy and film, I recommend that you read several simple how-to guides that explain the basics of photography. You'll also want to read any manuals that come with the equipment you purchase to ensure maximum proficiency.

Sometimes quality photographs can be taken outdoors in daylight using only a handheld camera. However, unpredictable lighting and inclement weather often leads to uneven and inconsistent photographs that don't do your painting justice. Inconsistent lighting can be a particular problem if photographing a step-by-step process or paintings in a series, as the changes in the lighting will affect the colors and values of the pieces being photographed. To avoid such frustrations, you can photograph your work indoors. Simply choose a comfortable space in your home or studio where you can arrange a permanent photographic setup. With just a 35mm camera, a 28-80mm zoom lens, interchangeable close-up lenses (58mm works well for smaller paintings), several rolls of professional-grade tungsten film, a sturdy tripod, two photo lamp holders and several 500 watt/3200 Kelvin photoflood bulbs, you can obtain consistent and quality results without the help of a professional!

Getting It Square
One of the most common mistakes made by casual photographers is not getting the image square in the photograph. To square up your shot, aim the camera lens directly at the center of and perpendicular to the artwork, both vertically and horizontally.

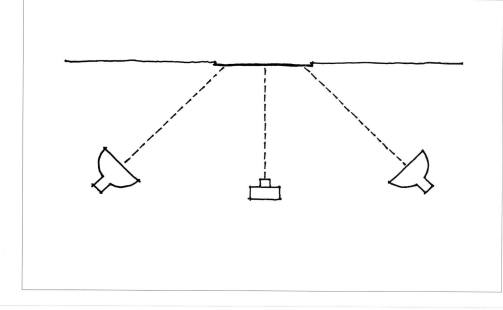

Lamps/Camera/Art Layout

This diagram shows an effective relationship between artwork, camera and photo lamps. The camera view should be perpendicular to the artwork, both horizontally and vertically, and aimed directly at the center of the piece being photographed. The lamps should be set equidistant from and at approximately 45° (horizontal) to the artwork. If the lamps are set the same height as the camera, they usually provide uniform illumination of the artwork and minimize adverse glare from the surface of the piece being photographed. Large pieces may require more care to ensure that the illumination is uniform.

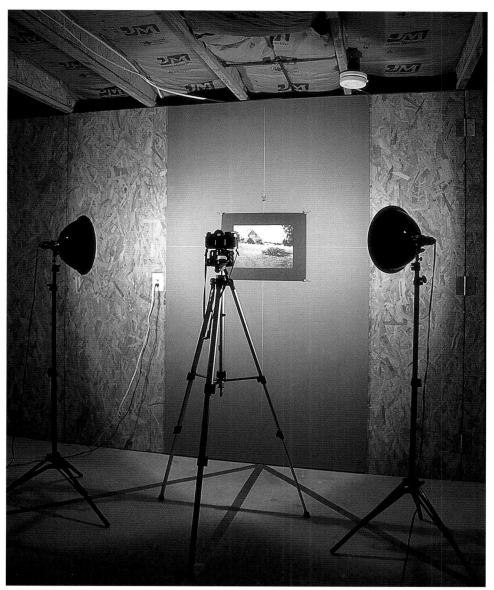

The Setup

Your setup doesn't have to be fancy. Simply choose a dry, reasonably dust free space that is easily accessible to you. Here I applied a sheet of gypsum board to a wall in my basement and painted it gray so that it will reflect very little light. I then drew vertical and horizontal registry lines on the board using a white pencil. This makes it much easier to center the work being photographed. The duct tape on the floor makes horizontal alignment of the camera tripod and lamp holders quick and easy.

117

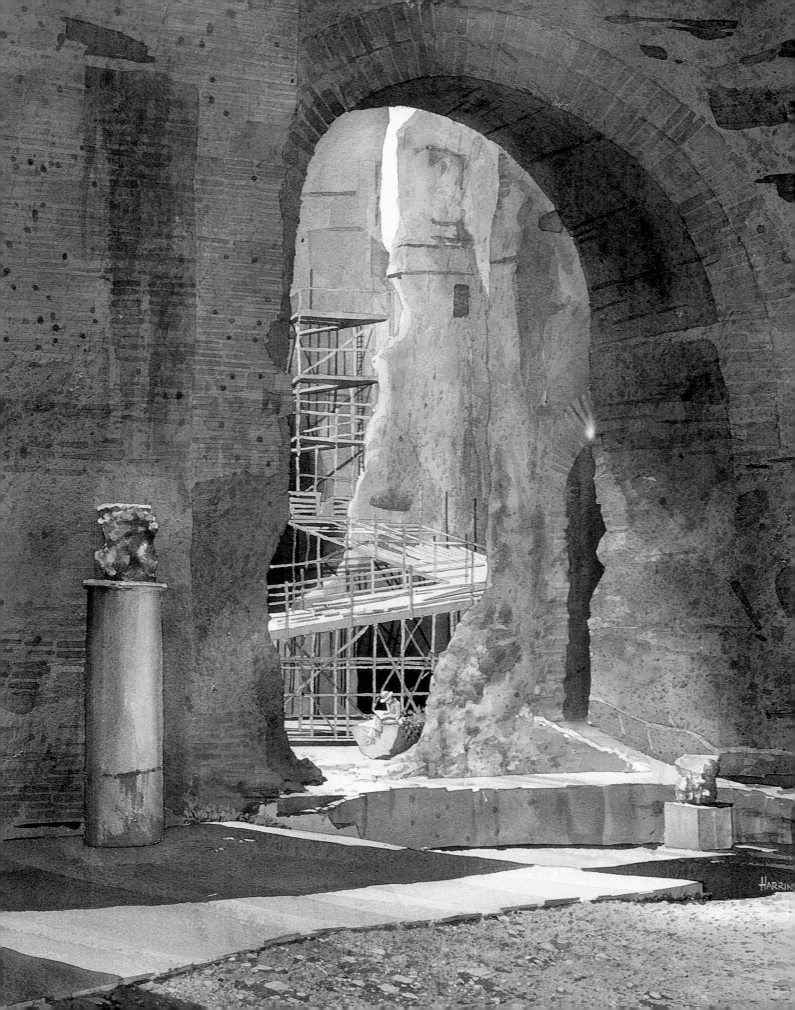

CONCLUDING REMARKS

The methods and techniques discussed in this book are not only useful for the novice painter. In fact, they continue to assist me in my life-long pursuit of becoming a better painter. It is my hope that you will benefit from these lessons as well, further developing your skills and realizing your own artistic goals. With that said, I'd like to conclude by giving you three bits of advice that I wish someone had given me when I first decided to become a painter.

There are no magic formulas or shortcuts to achieving success. Success is the result of diligence, hard work and a persistent willingness to learn. Most of the knowledge and skills that you acquire will come from two sources: fellow artists who have obtained a degree of mastery through study and experience and your own hands-on experiences. Both are essential sources.

Be an innovator, not an imitator. An interesting question that I often ask students at the beginning of a class is "how many of you know who Elvis Presley was?" Of course all hands indicate yes. I then ask "how many of you can give me the name of one Elvis impersonator?" Despite the fact that there are many gifted Elvis impersonators, my students are unable to name even one. What's the point of this story? There was only one Elvis and there is only one you. You are unique just as sure as Elvis was unique. In other words, learn from other artists, don't imitate them.

Don't be afraid to fail. Failure is never fatal or final. A failed painting is a great learning experience. Oftentimes you'll learn as much from your failures as you do from your successes. It's easy to give up when things aren't going as you'd hoped, but if you're persistent you will succeed.

I wish you the best of luck in all your painting endeavors.

Charles Harrington

BATHS OF CARACALLA
Arches 300-lb. (640gsm) cold-pressed watercolor paper / 29" x 21" (74cm x 53cm)

Gallery

CLAY POTS
Arches 300-lb. (640gsm) cold-pressed watercolor paper / 21" x 29" (53cm x 74cm)

LOUISIANA BACKLIGHT
Arches 300-lb. (640gsm) cold-pressed watercolor paper / 29" x 21" (74cm x 53cm)

R U I N S
300-lb. (640gsm) cold-pressed watercolor paper / 9" x 12" (23cm x 30cm)

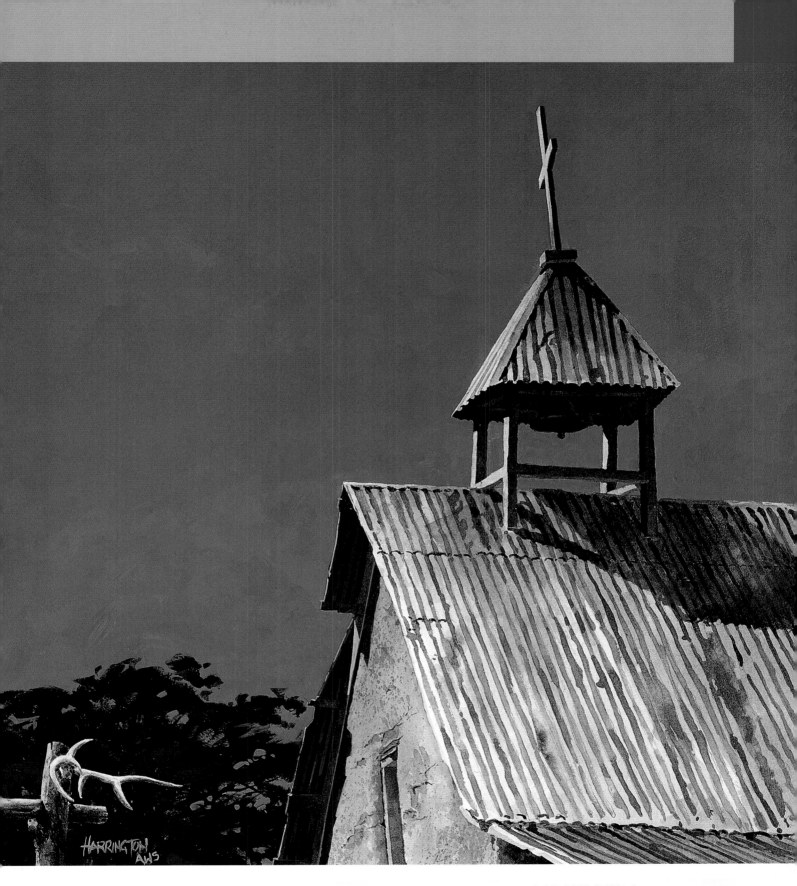

CROSS OVER GOLONDRINAS
Arches 300-lb. (640gsm) cold-pressed watercolor paper / 21" x 21" (53cm x 53cm)

ON BATHHOUSE ROW
Arches 300-lb. (640gsm) cold-pressed watercolor paper / 21" x 29" (53cm x 74cm)

PAIGE'S FRIENDS
Arches 300-lb. (640gsm) cold-pressed watercolor paper / 21" x 29" (53cm x 74cm)

Index